LEICESTERSHIRE
THROUGH TIME
Stephen Butt

BRADWELL
BOOKS

First published in 2012 by
Amberley Publishing for Bradwell Books

Amberley Publishing
The Hill, Stroud
Gloucestershire, GL5 4EP
www.amberley-books.com

ISBN 978 1 4456 0822 8

British Library Cataloguing in Publication Data.
A catalogue record for this book is available from
the British Library.

Typeset in 9.5pt on 12pt Celeste.
Typesetting by Amberley Publishing.
Printed in the UK.

Introduction

To reflect accurately the character and nature of Leicestershire in a collection of old and new photographs is no mean task. A few generalisations may be possible, such as the county's landlocked position and its undulating landscape, and the influence of the Roman roads and the rivers on the location of its settlements, but then there are always the exceptions to every rule. So the unusual and the exceptional must be included, as well as the famous and the familiar.

The names of Leicestershire's villages and towns tell the history of their origins, sometimes Saxon, sometimes Danish, occasionally a combination of both, and often with a later Norman attribution. The very earliest settlements are here too, on the high places, notably the Iron Age hill fort at Burrough on the Hill.

The entire alphabet – except for 'X' – is represented in the county's names, from several settlements called Ashby, to Zouch in north-west Leicestershire, with some surprises on the way including Albert Village and John O'Gaunt.

Often hidden away from view in a quiet valley are the religious houses. Leicestershire has nothing to compare with the grandeur of England's major abbeys, but there is beauty and dignity in the ruins at Ulverscroft, and a remarkable sense of peace and antiquity in the relatively modern Mount St Bernard's Abbey designed by Augustus Pugin.

The county has its thriving market towns – Market Harborough, Lutterworth, Hinckley, Shepshed, and Loughborough – which have survived economic downturns on many previous occasions before the crises of the twenty-first century. In Leicestershire, these towns are located almost equidistant from the city of Leicester on ancient routes spreading outwards from the centre like the spokes of a wheel. Loughborough has embraced academia and technology and has a major airport nearby; Market Harborough has retained a certain quaintness and charm although it has lost its earlier staple industries.

Most of the older images in this collection are from the postcards of the late nineteenth century and the following two decades, but several earlier photographs have been included because of their rarity. A number of the photographs, mainly of buildings with a significant architectural interest, were taken by Frederick Attenborough when he was Principal of University College Leicester, now Leicester University. These mostly date to the 1940s when he travelled extensively around the county, often accompanied by William Hoskins, who is regarded as the father of English Local History as an academic study. These photographs were then used by the Leicester School of Art, later Leicester Polytechnic, in the teaching of architecture, and are now part of the Archives of De Montfort University.

This collection does not constitute a complete survey of Leicestershire. Nor is it a gazetteer. It is intended as a gathering together of images of interest, some familiar and some little-known, of different building styles from castles to cottages, and reflecting both the rural and urban landscape. It is a record of both change and of how the essence of an English county does not change, even when its ancient houses have been demolished or large housing estates have been built.

In Leicestershire, a hunting county, the photographer often perceived the countryside on horseback, giving an elevated view above hedgerows. In the towns, the first professional photographers would seek permission to place their tripods above street level, in bedrooms and on balconies. On the estates, the stately manor houses and halls would often be taken from a low perspective to provide a satisfactory impression of grandeur and splendour for the owners.

As with every collection and every history, this cannot be all my own work. I have depended upon advice and information from so many individuals as well as the standard antiquarian histories of Leicestershire. I must thank all those villagers whom I have interrupted by knocking on their doors, seeking permission to photograph their homes, as well as those institutions and organisations which have willingly loaned me images and information, including the Archivist of De Montfort University, the Great Central Railway, the Leicestershire Archaeological and Historical Society, and listeners to BBC Radio Leicester.

Stephen Butt

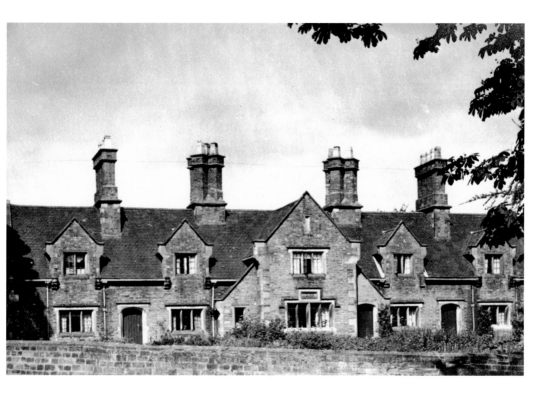

Appleby Magna Almshouses
This is a fine example of social housing of the nineteenth century. These almshouses were built by two sisters, the aunts of the lord of the manor, to provide a home for their retired servants. Many would otherwise have ended their days in the workhouse.

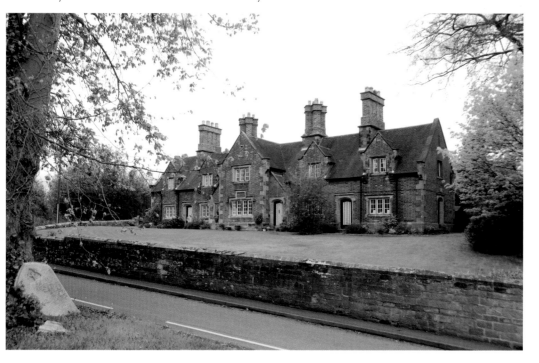

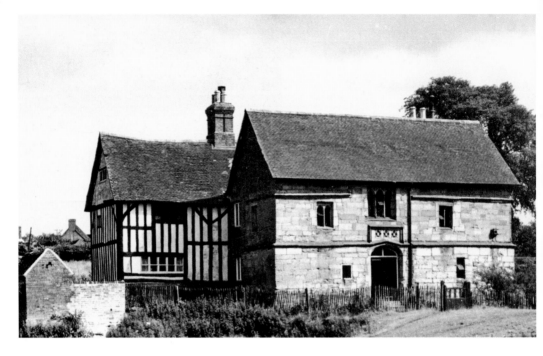

Appleby Magna Manor House

The earlier photograph is by Frederick Attenborough, father of Sir David and Lord Attenborough, when he was principal of University College, Leicester. This is a remarkable survival from the early fifteenth century, a moated homestead of a medieval squire. The half-timbered section was added in the mid-sixteenth century.

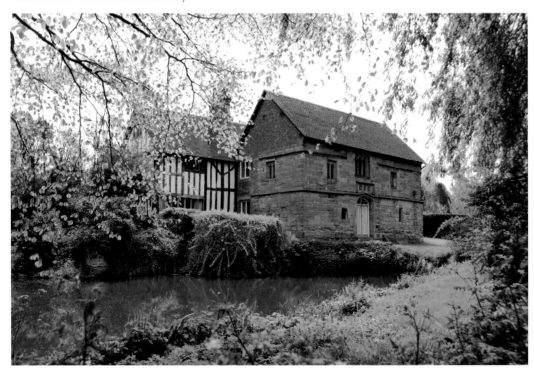

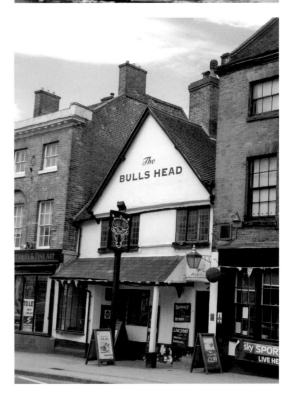

Ashby de la Zouch, the Bull's Head Inn
Dating from 1598 and standing in the
centre of Market Street, the Bull's Head
is thought to be the oldest building in
this historic town. Grade II listed, a
'penthouse' was added in the nineteenth
century, but much of the original timber
frame construction has survived and can
be seen inside the building.

Ashby de la Zouch – the Hood School

The Hood School was built on South Street in 1807 and for many years served as an annexe to the Ashby Grammar School where Sir Joseph Hood was educated. Hood was a major benefactor to the town as well being a prominent businessman and Conservative politician.

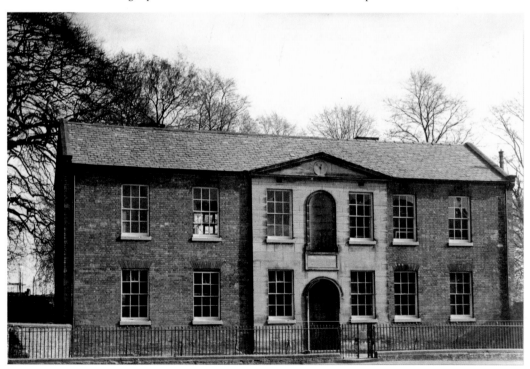

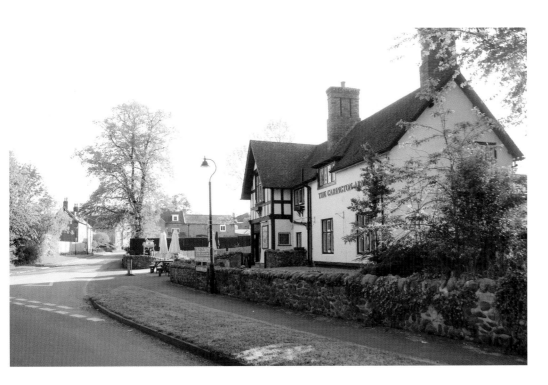

Ashby Folville, the Carington Arms
The Carington family descended through the Smith and Woodford families from the Folvilles who gave their name to the village. The quartered arms on the side of the pub tell the story. The five Folville brothers were responsible for some of the most notorious crimes of the fourteenth century. Their name ultimately derives from *Folleville* in the French area of Picardy.

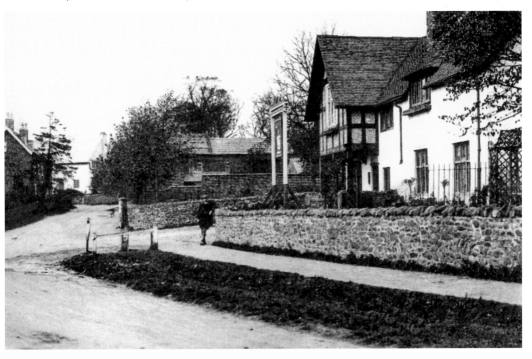

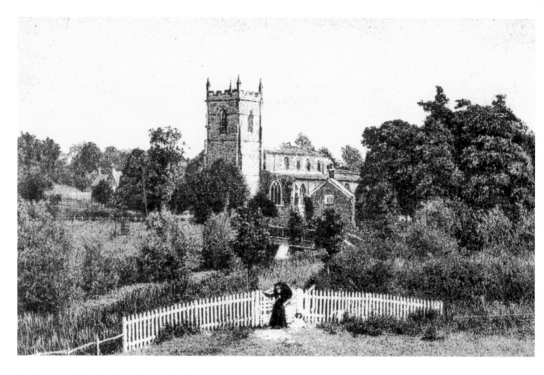

Ashby Folville, St Mary's Parish Church
Despite his life of crime including several murders, Eustace Folville lies buried in the chancel. Here also is Sir Ralph Woodford, one-time lord of the manor and Sheriff of Leicestershire, from whom the author of this book descends.

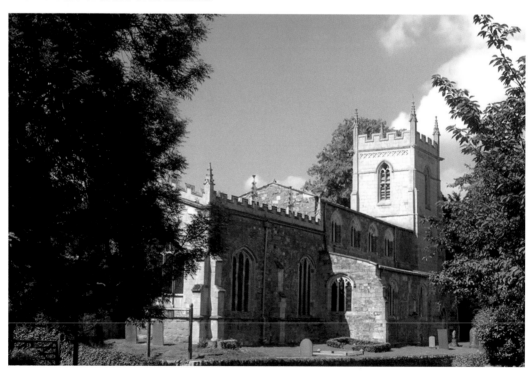

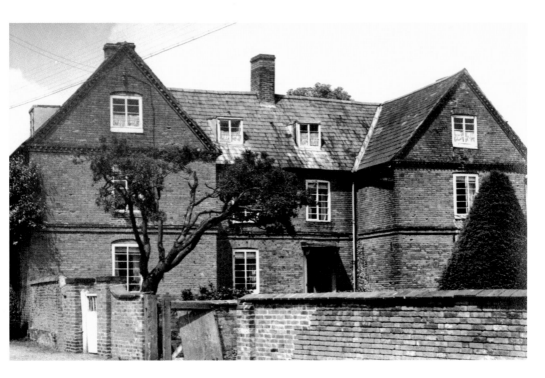

Ashby Parva Manor Farm

Ashby Parva has always been a small settlement, and yet the Manor Farm is a large and impressive building suggesting considerable wealth. It is almost certainly on the site of an earlier structure dating to after the village was enclosed in 1665.

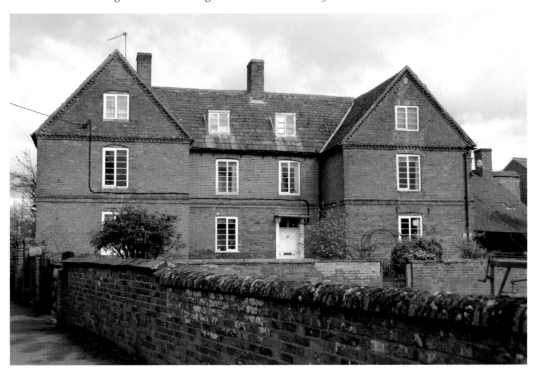

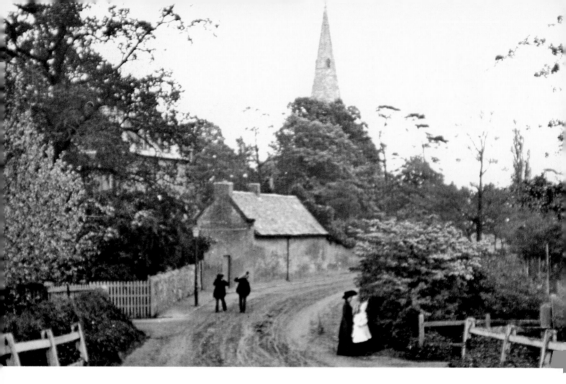

Aylestone Bridge and Parish Church

Aylestone has lost much of its village identity, having been totally subsumed into the city of Leicester, but it was a thriving settlement before Domesday. Away from the main commuter routes, its village atmosphere can still be found.

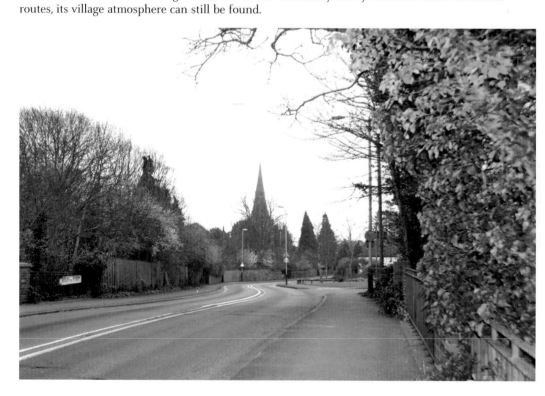

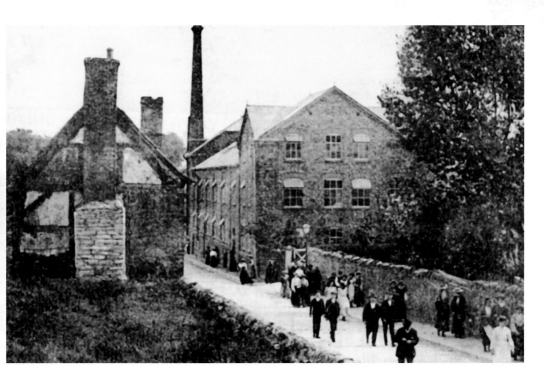

Barrow-on-Soar, Charnwood Mill
The building remains, dominating the residential landscape of Sileby Road, but the workers walking slowly home at the end of a shift is an image of a past era. Textile manufacture was the major employer in this and other villages north of Leicester in the Soar Valley.

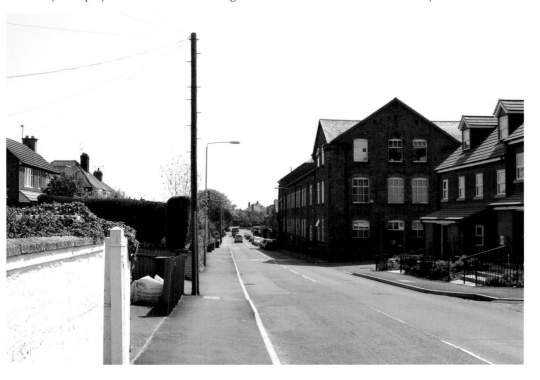

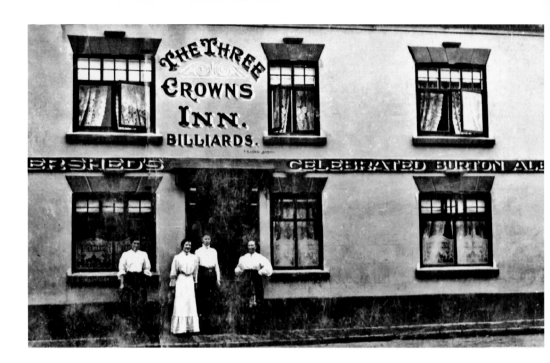

Barwell, the Three Crowns
The landlord and his family pose happily in front of their hostelry at the very beginning of the twentieth century. The building is now a private residence following careful restoration and refurbishment. The pub name probably derived from the arms of the Worshipful Company of Drapers, underlining Barwell's previous importance as a centre for the hosiery and textile industry.

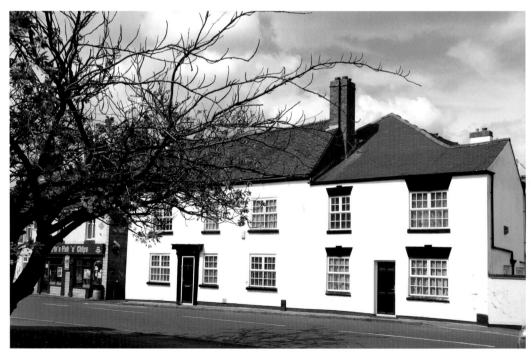

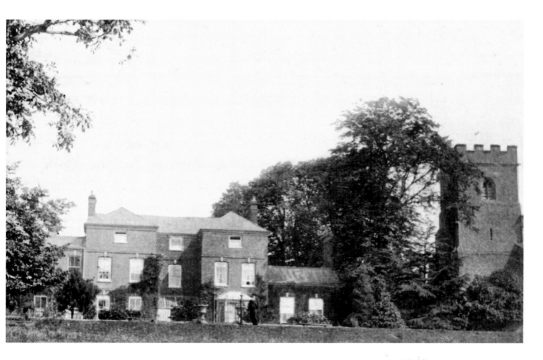

Barwell, St Mary's Parish Church and Rectory

On Christmas Eve in 1965, a meteorite shower landed on Barwell. One piece seriously damaged a vehicle. It was deemed an 'Act of God' by the driver's insurance company who then directed his claim to the parish church: 'If it was an Act of God, the Church should pay for my car.' The priest refused to pay up. The earliest part of the church dates to the thirteenth century and there is a complete record of the rectors since 1209.

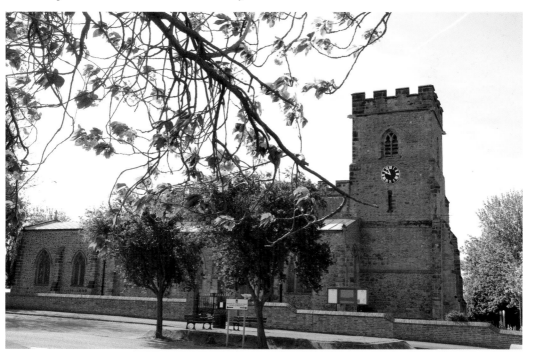

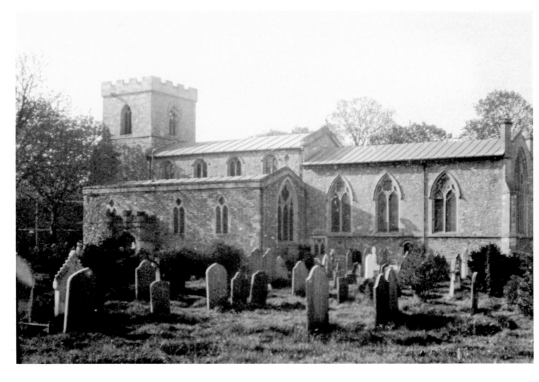

Belgrave, St Peters Parish Church

Once situated on the main road from Loughborough to Leicester, the world has now bypassed Belgrave, and the village now comprises little more than the hall and house, pub and church. Consequently, this lovely medieval church closed in 2011, in much need of remedial work to its roof.

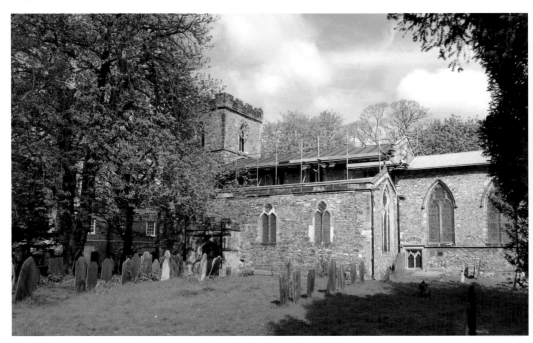

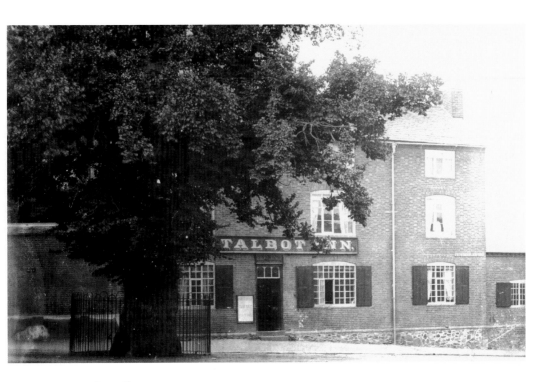

Belgrave, The Talbot Inn

Convicted criminals on the way to the gallows at Red Hill would be allowed a last drink here, which may account for the many stories of haunting and ghostly sightings which have made this pub famous. A serious fire led to the demolition of the upper storey. This earlier photograph was taken in 1873.

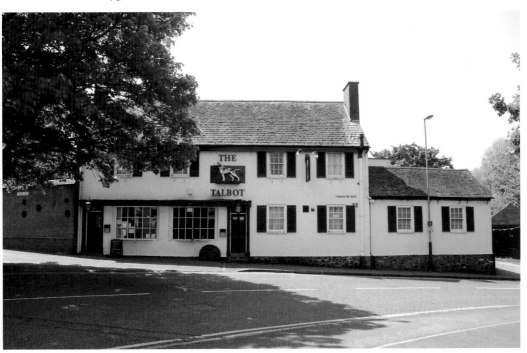

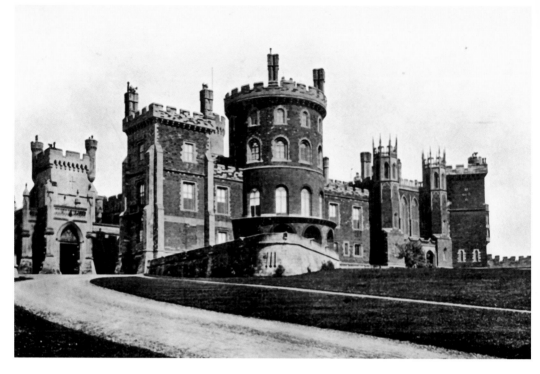

Belvoir Castle

Although a fortified residence has been on this site since the Norman period, the present castle, seat of the Duke of Rutland, dates from the early nineteenth century. Its impressive elevation and extensive lands has made Belvoir Castle a popular location for Hollywood film makers.

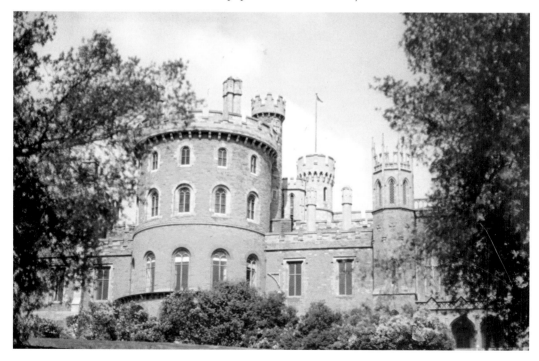

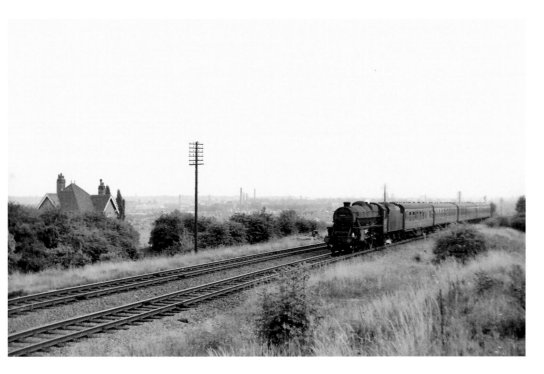

Birstall, the Sidings at Leicester North
This is a telling example of a changing landscape. The railway embankment which took trains on the Great Central Railway across Leicester has gone. The gap in the hedgerow marks the original path to the former stationmaster's house, now demolished. In the very far distance is the tower of the National Space Centre. This is now the approach to the Leicester terminus of the GCR steam heritage railway.

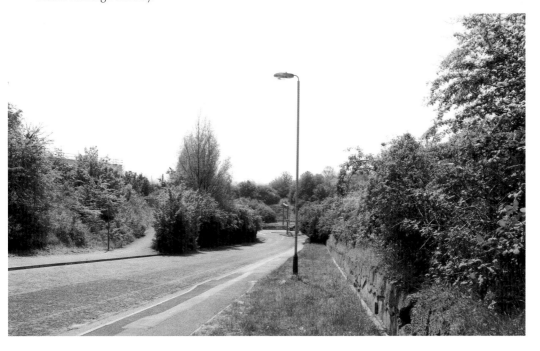

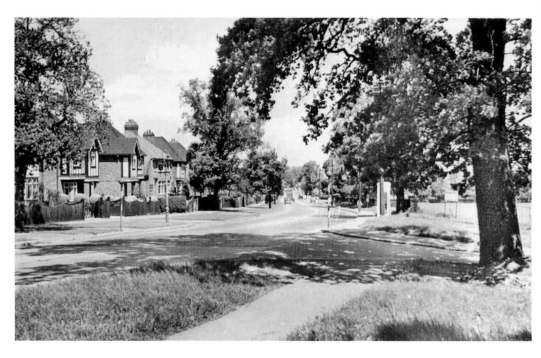

Birstall Loughborough Road

Birstall is described officially as a Charnwood village, but it also part of the Leicester urban area. Located on the main route to Loughborough, Birstall has to contend with constant commuter traffic, and therefore this principal junction is frequently reshaped and refurbished. The trees on the left in the distance were planted to commemorate opening of St Theresa's Catholic Church in 1982.

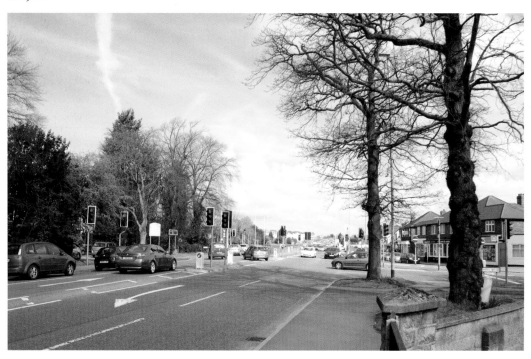

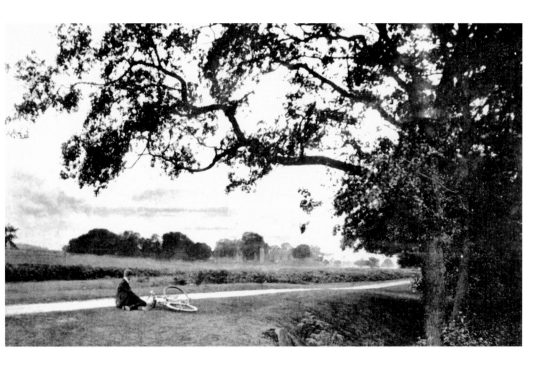

Bradgate Park and the Ruins of Bradgate House

The house in the far distance is said to have been the birthplace of Lady Jane Grey whose family inherited Bradgate in 1445. It remained in their ownership until 1928 when it was gifted to the people 'to be preserved in its natural state for the quiet enjoyment of the people of Leicestershire'.

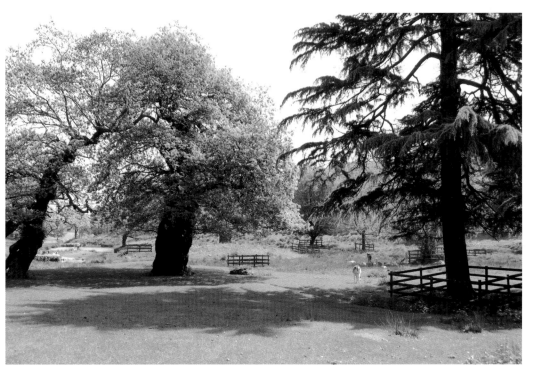

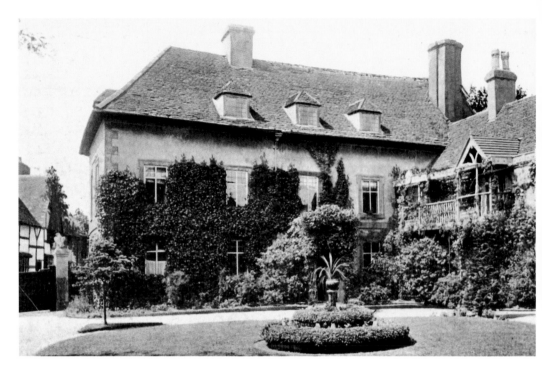

Burbage Hall

A Grade II listed building, Burbage Hall dates to the early eighteenth century. Set close to the village church but away from the main street (on the lane to Aston Flamville), and in exquisitely landscaped gardens, the hall has a remarkable sense of peace and tranquillity. Kinard Bagot de la Bere, the engineer who discovered isinglass as a preservative, lived here from 1879 until 1904.

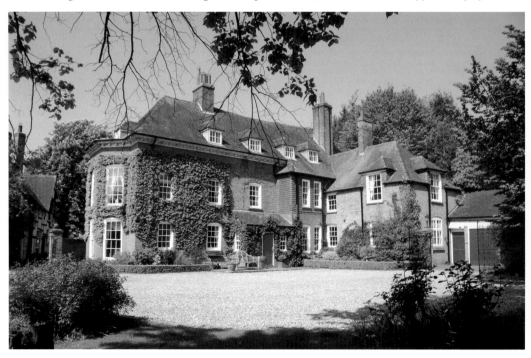

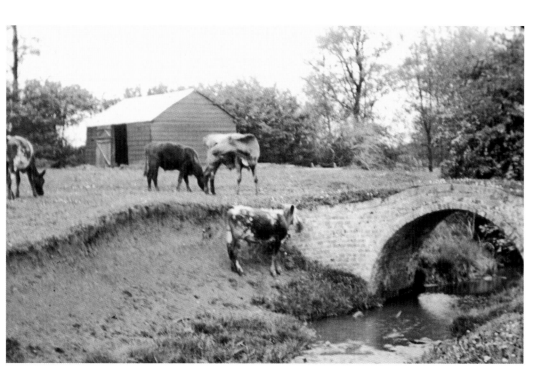

Burton Overy, the Wash Brook

The Burton Brook is an important topographical feature of south Leicestershire, and was a vital part of farming life. It is less obvious now, but still meanders across the northern boundaries of the village. In the churchyard is a memorial with music from Handel's *Messiah* which received its first performance in an English parish church in nearby Church Langton.

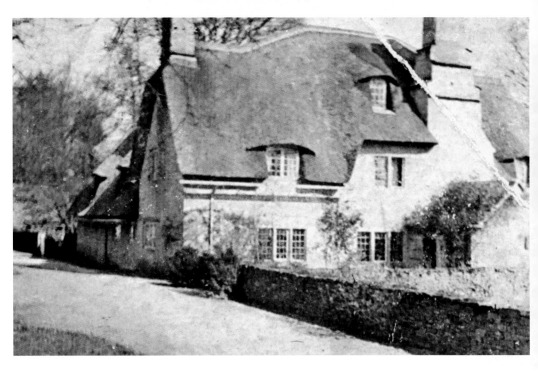

Charnwood Lea Cottage I

Despite being just two miles away from the M1 motorway, this cottage in the delightfully-named Polly Bott's Lane seems remote and isolated in time. The earlier photographs are by Frederick Attenborough, who was interested primarily in the building's architectural inheritance.

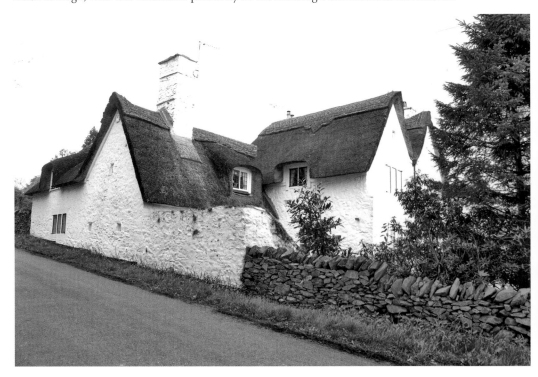

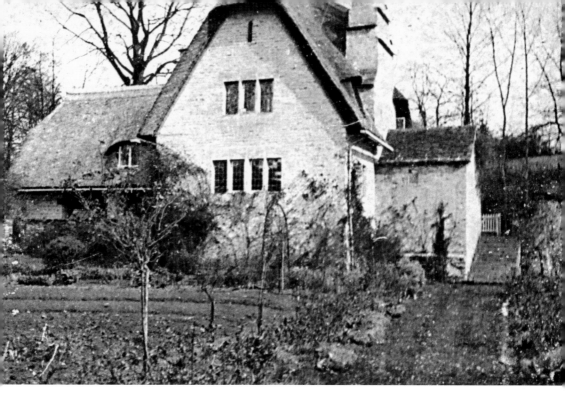

Charnwood Lea Cottage II

This cottage is located on the edge of Lea Meadows and Lea Wood, an important historical site first mentioned in 1287. It is a moated site with a large rectangular island, the moat supplying a complex system of channels and enclosures.

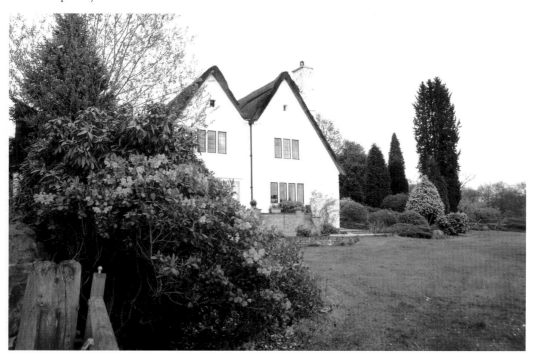

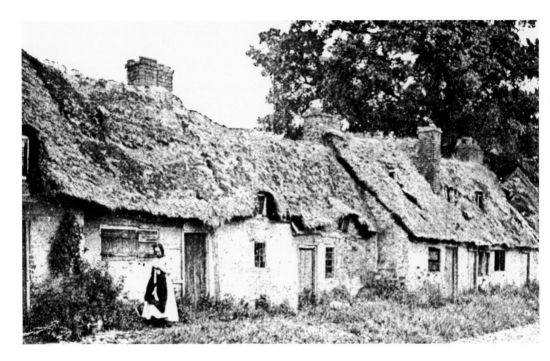

Cossington Cottages

Cossington, in the Soar Valley, has been a centre for textile manufacture for centuries dating to when it was primarily a cottage-based industry. Even after mechanisation, many of the cottages in the village had a 'Grissy' or Griswold, a machine for knitting socks which could be clamped to the kitchen table.

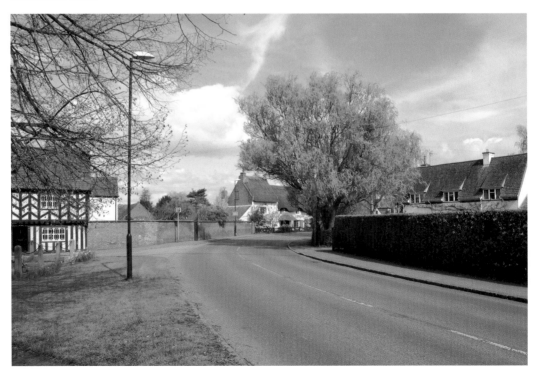

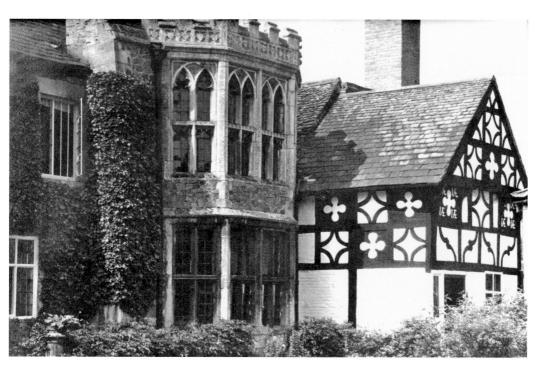

Cossington Rectory

Hidden from view behind the parish church, this fine house dates from the fourteenth century with additions over the next four centuries. It has probably been protected from later development by its position, set back away from the main road through the village.

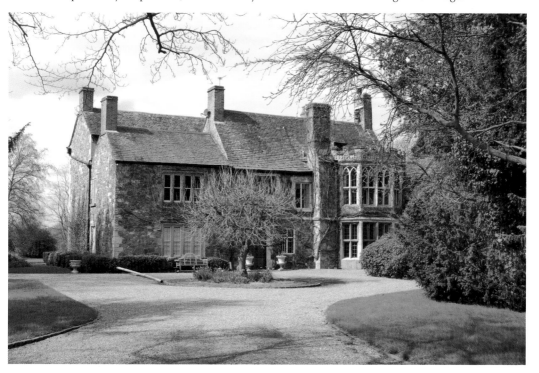

Earl Shilton, St Simon and St Jude Parish Church

Before 1854, Earl Shilton was part of the ecclesiastical parish of nearby Kirby Mallory with just a humble chapel of its own in the hall field. In 1855 a new parish was created and the present parish church was built on the same elevated site at a cost of £3,500, paid for by the Noel family of Kirby Mallory.

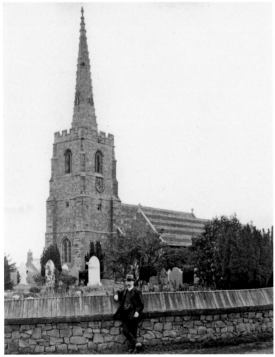

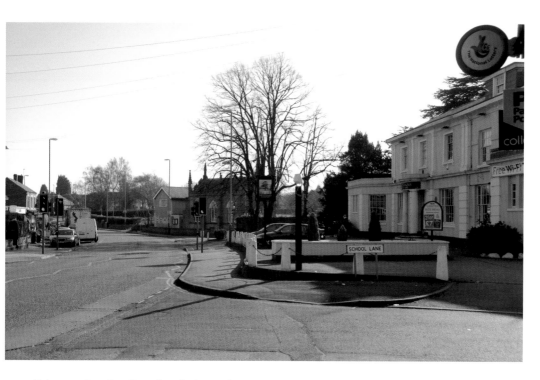

Evington Baptist Chapel and The Cedars

The nineteenth-century crime novelist E. Philips Oppenheim lived at The Cedars which is now a pub. His daughter, Josephine, was born here. The little Baptist Chapel was built in the Gothic style in 1837. The Manse, next to the chapel, was demolished in the 1960s due to road-widening.

Evington, Shady Lane
Shady Lane, by name and by nature, connects Evington with the Roman Gartree Road. The young man resting on the parapet of the bridge looks somewhat over-dressed. He was possibly an employee of the nearby Powys-Keck estate. The bridge, now masked in ivy, was rebuilt in the 1930s.

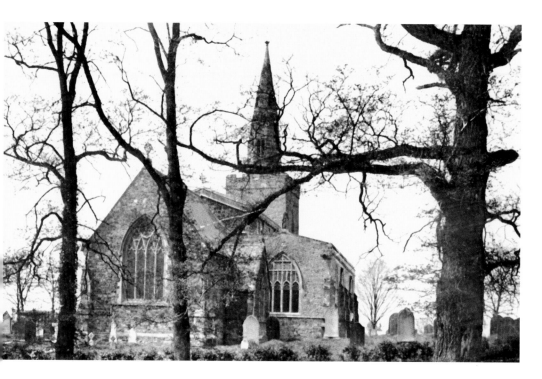

Evington, St Denys Parish Church
Dr Cyril Bardsley, the first Bishop of the re-created Diocese of Leicester, is buried here. The foundations of the church were laid down in about 1200, and the church was consecrated by the Bishop of Lincoln on 9 October 1219.

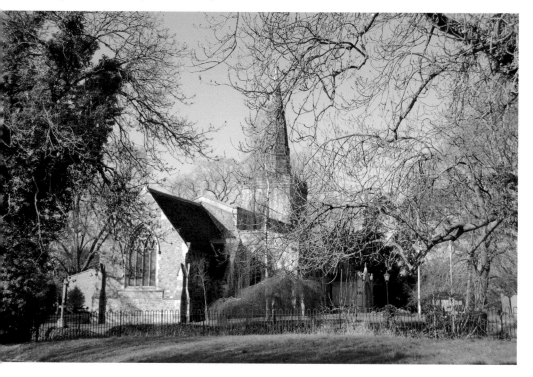

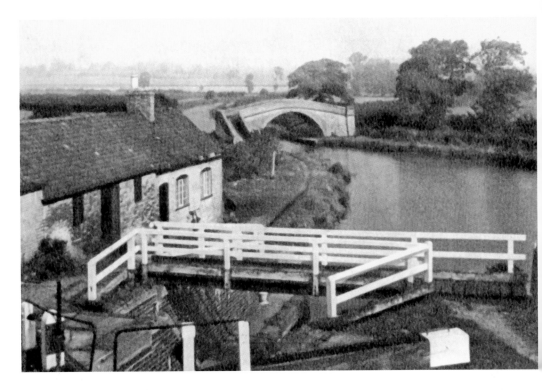

Foxton Locks

Once a busy junction and staging point on the Grand Union Canal, the staircase locks at Foxton are now a national tourist heritage attraction, their tranquil beauty a far cry from the noise and industry of the Victorian age.

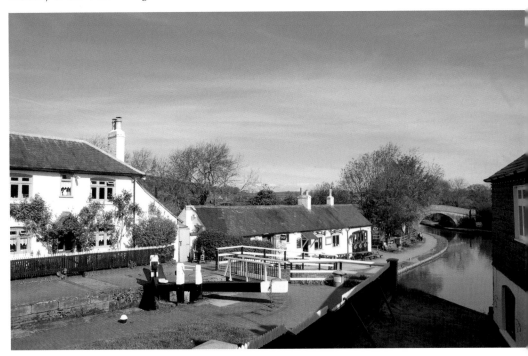

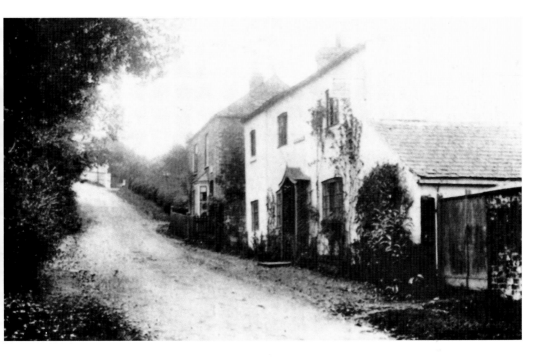

Foxton Main Street
The village of Foxton was changed forever when the canal was cut through, creating new roads and bridges. The natural rising landscape of Main Street to towards the church was enhanced to provide a bridge over the canal.

Groby Castle

This is a site with a long and fascinating history. The castle was destroyed before 1200 on the orders of Henry II. A stone manor house was built soon afterwards. In 1485, Thomas Grey constructed a new brick gatehouse which became part of what is now the Old Hall. Most recently, a bypass has crossed part of the site and a modern office complex has been built next to it.

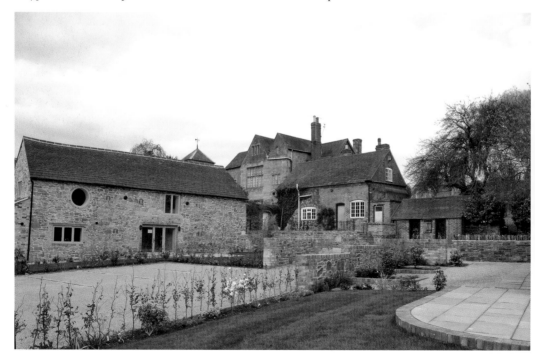

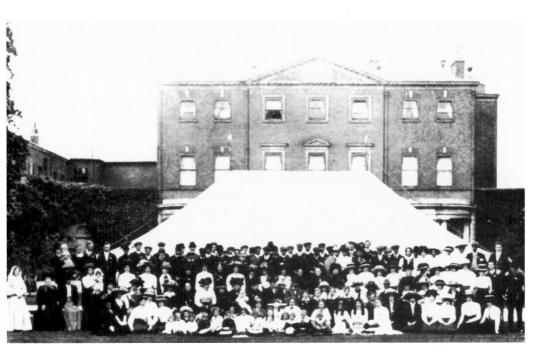

Gumley Hall

Gumley has a fascinating history. Here, King Aethelbald of Mercia held a synod in AD 749. Near to the site of the hall is a pond known as The Mot which may be of Saxon origins, and it is known that King Offa attended a Witanagemot for the kings of Mercia here in 772 and 779. The hall was built in 1764 for Joseph Cradock, and demolished in 1964 having never recovered from its military occupation during the Second World War.

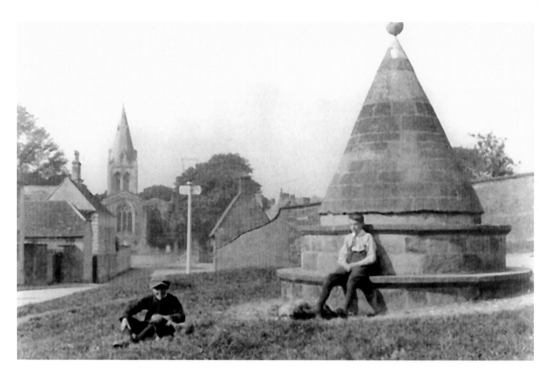

Hallaton Butter Cross

The Butter 'Cross' is not a cross, but a cone-shaped structure which has served as a meeting or moot point for the village for centuries. It has close associations with the ancient Easter Monday Bottle-kicking. The tradition of donating food to the poor is continued in a ceremony of giving penny loaves at the Butter Cross before the bottle-kicking contest begins.

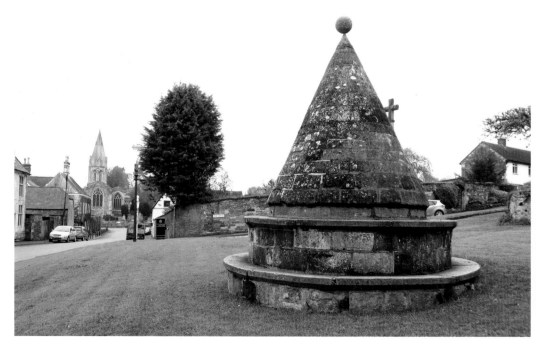

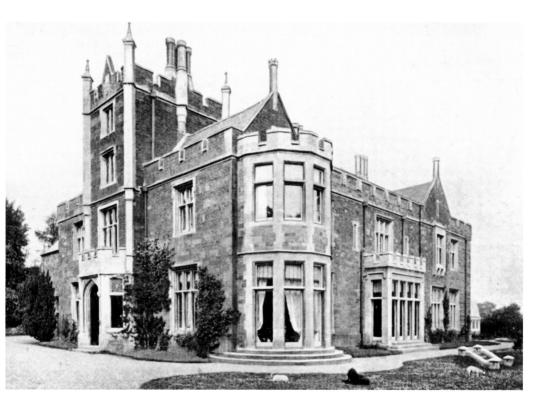

Hallaton Manor House

An impressive building in the Tudor style, but constructed in 1845. It is said to incorporate stone from its predecessor which was located in the centre of the village. After the Second World War, the house was owned for just three years by a Leicester antique dealer who sold it to the Sundial Nursing Home. It continues to serve as a specialist residential home today.

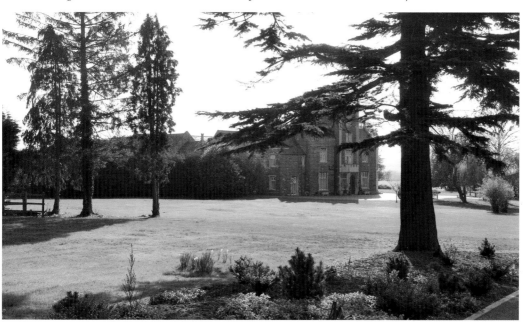

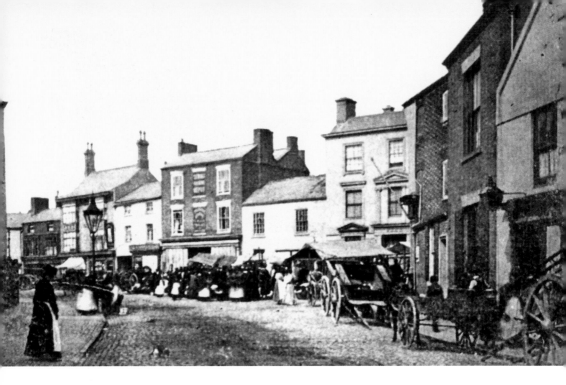

Hinckley, The Borough

Hinckley, on the southern borders of the county, derived its earlier wealth from textile manufacturing, particularly coarse hose and socks. The Borough links the main routes through the town with the historic market place. It has, over the past century, suffered from piecemeal commercial development.

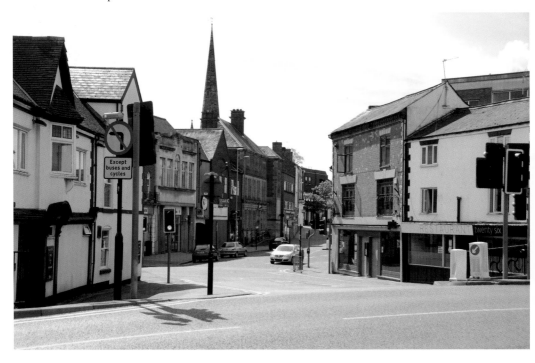

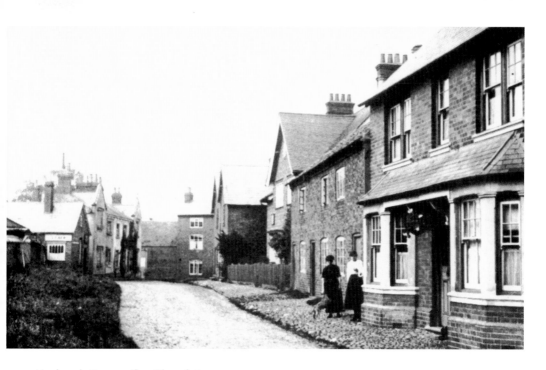

Husbands Bosworth – Church Lane

This view of Church Lane is from the church, and was taken in about 1920. The street was often known as Gilby's Lane after a plumbing and decorating business located here. The cottages behind the ladies have been demolished. The next house was built in 1902.

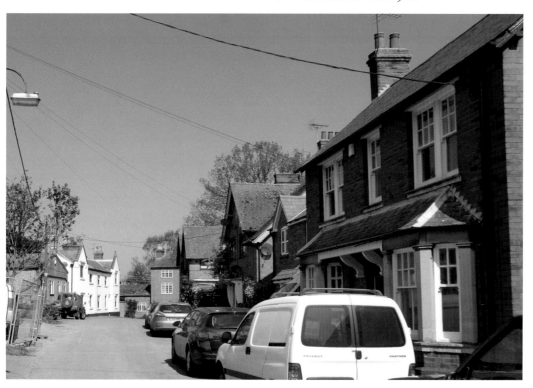

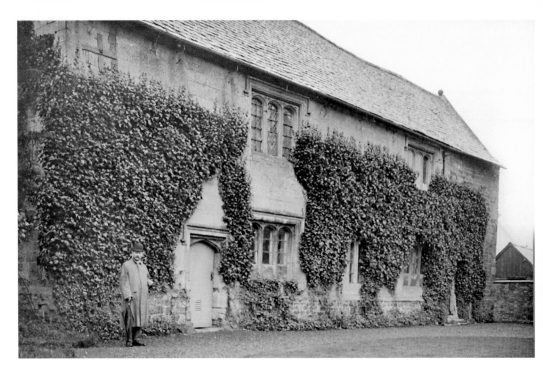

Ingarsby Barn

Ingarsby is one of the best preserved deserted medieval villages in England having been cleared in 1469 when Leicester Abbey enclosed much of its land. Around the site can be seen well-delineated rectangular mounds marking the house-sites of the arable farmers who were driven out, and the hollow ways where the village streets and lanes once ran.

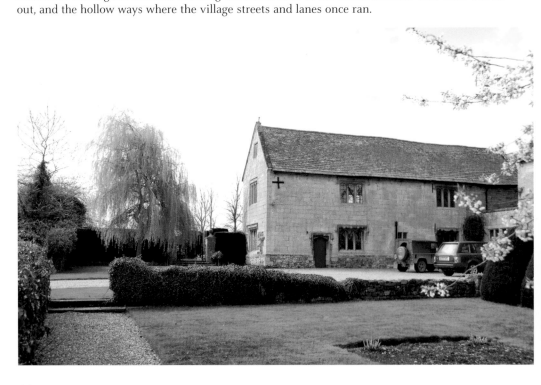

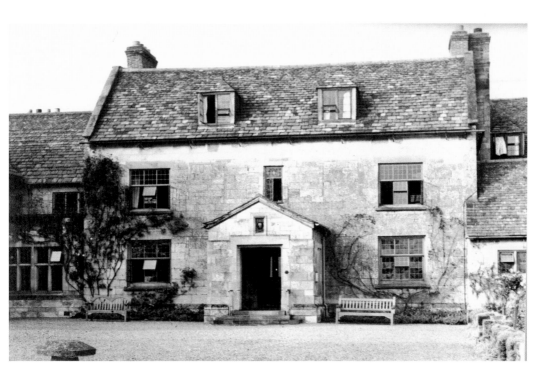

Ingarsby Hall

The Grange Farm of Launde Abbey from the mid-sixteenth century. Ingarsby Old Hall was built by Brian Cave when he acquired the manor after the Dissolution. Moated on three sides originally, the oldest fabric, in the east range, dates to 1540. Another range was added by Sir Robert Bannister who bought the manor in 1621.

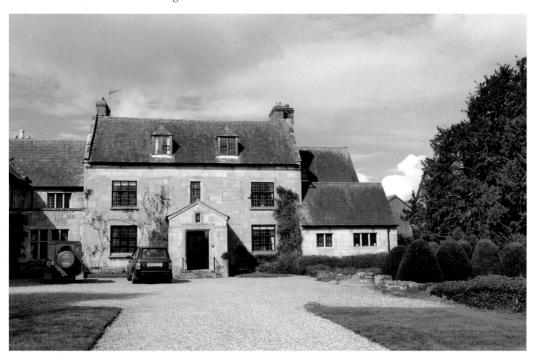

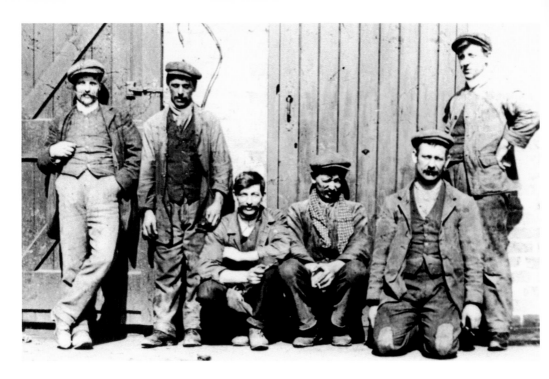

Kibworth Beauchamp, Gas and Coke Works

An evocative photograph, probably by Kibworth historian Bert Aggas, of stokers taking a break from their hard and tedious work. The gasworks opened in 1862 and went into voluntary liquidation exactly fifty years later, but continued to provide gas to the villages. For many years, a group of tall gasometers stood next to the office building which is now a private house.

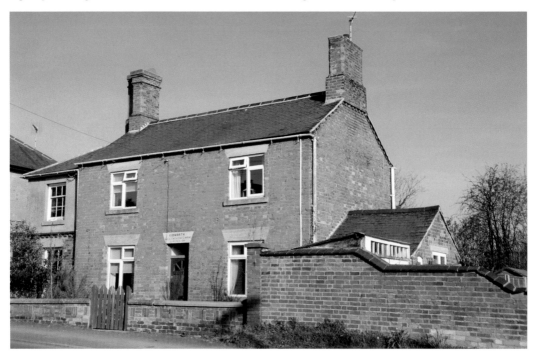

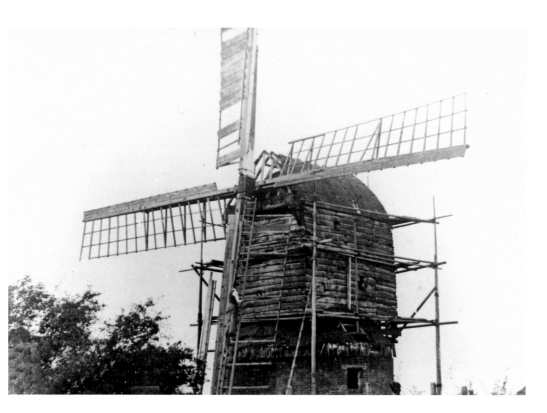

Kibworth Harcourt Windmill

The main post of the mill, constructed from a single tree trunk, has 1711 carved upon it, and this is probably the date of its construction. However, it could date from the early seventeenth century, and part of its structure may have come from another nearby location. It was saved from demolition in 1936 by the Society for the Protection of Ancient Buildings.

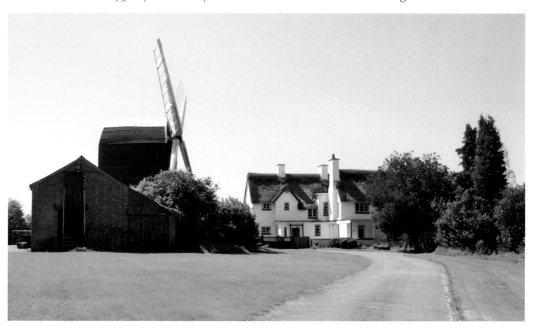

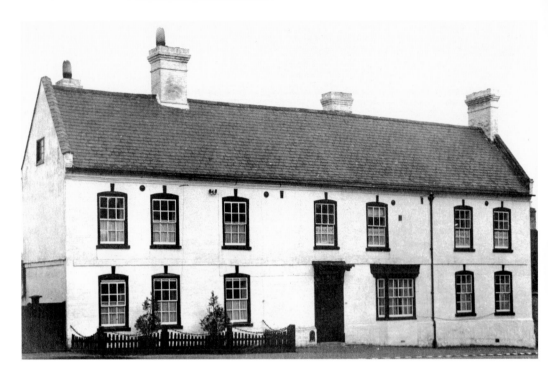

Kibworth Harcourt, The White House

The White Horse is a building with a long and complex history. It was formerly the home of the Congregationalist Dissenting Academy of John Jennings but for some years was also 'The Crown', a coaching inn. It became the residence of the village doctor, and it is said to have a resident ghost, the victim of either a tragic accident or possible murder. Now only the end wall is white, and the original front windows have been restored.

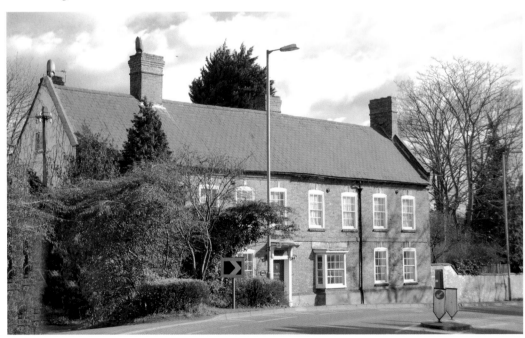

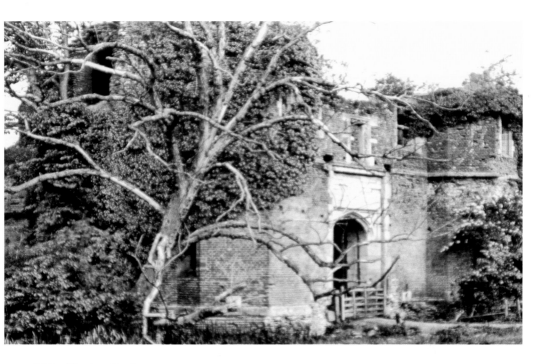

Kirby Muxloe Castle

An unfinished fortified manor house was begun in 1480 by Lord William Hastings, who was executed by Richard III in 1483. His descendants still believe they have a direct line to the throne of England. Fragments of the foundations of an earlier manor house can be seen within the enclosure of the castle. Today, the castle is cared for by English Heritage and the moat is a popular location for local anglers.

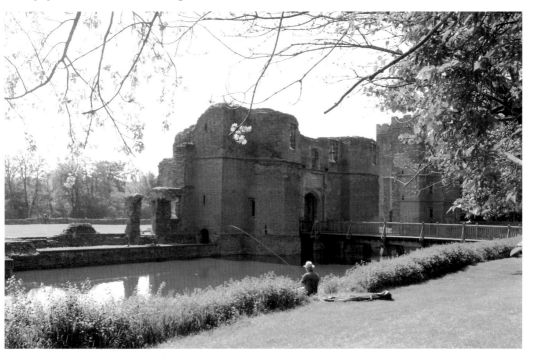

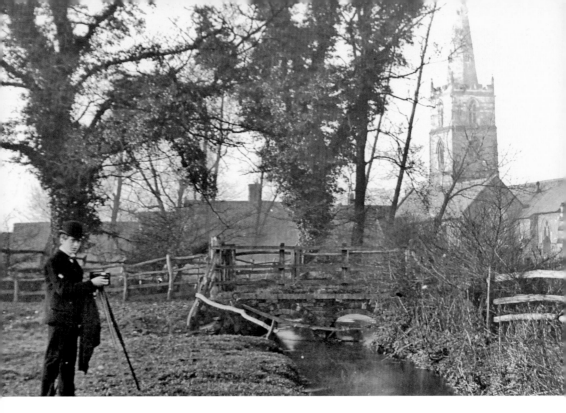

Knighton Brook and the Parish Church of St Mary Magdalene

This photograph was taken in 1893. The photographer's companion adds a sense of perspective. The church was refurbished less than a year later. The Knighton Brook is ancient and may have been used in Roman times as a conduit supplying water to Leicester. Wash stones, retrieved from the brook, are now part of a monument located next to the bridge which commemorates recent renovation of the watercourse.

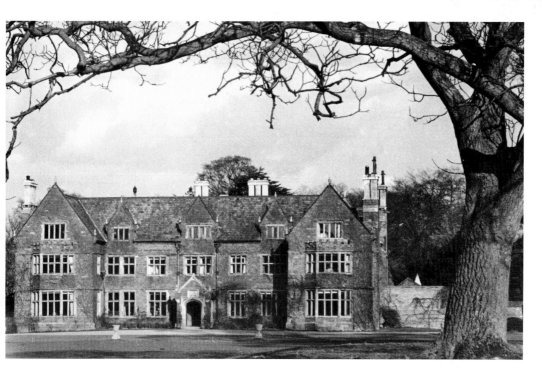

Launde Abbey

Launde is an Elizabethan manor house which now serves as an Anglican Retreat for the dioceses of Leicester and Peterborough. The twelfth-century chapel is the only remaining part of the original extensive priory. Originally founded in 1125, it was demolished mainly by Gregory Cromwell, son of Thomas Cromwell and his wife Elizabeth, sister of Jane Seymour, in the mid-sixteenth century.

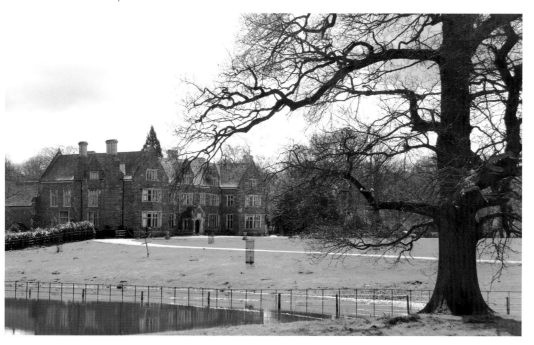

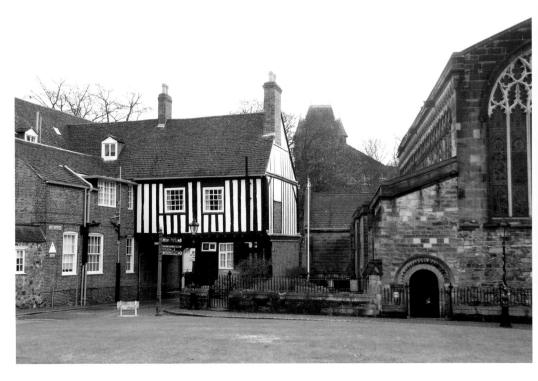

Leicester Castle Green

Townspeople no doubt gathered here to watch historic events. It has been a place of execution, a pulpit for John Wesley, and where dukes and monarchs met. Henry VI was knighted in the Church of St Mary de Castro, and possibly Geoffrey Chaucer married Philippa de Roet here.

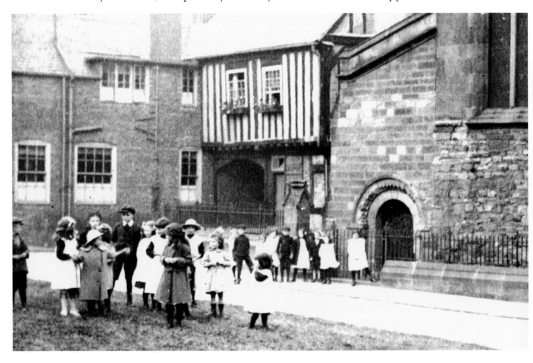

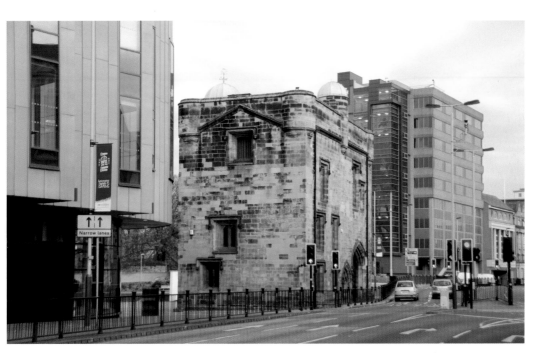

Leicester Newarke Gateway

Often known as the Magazine Gateway because of its use as a storage area for gunpowder during the Civil War, and as a regimental museum in the twentieth century, it was built in about 1410 by Henry, third Earl of Lancaster and Leicester. In 1331 the Earl had provided four acres of land outside the town and next to his castle for a hospital to care for the sick and elderly. Today the gateway stands overlooking the Magazine Square of De Montfort University, and the hospital houses the university's administration.

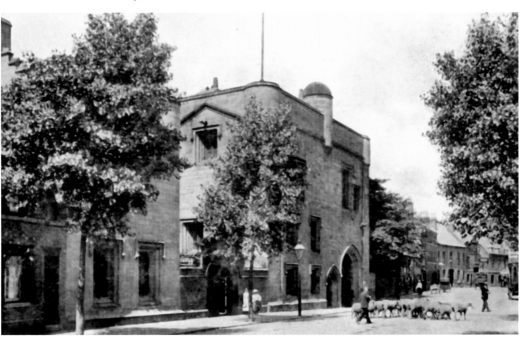

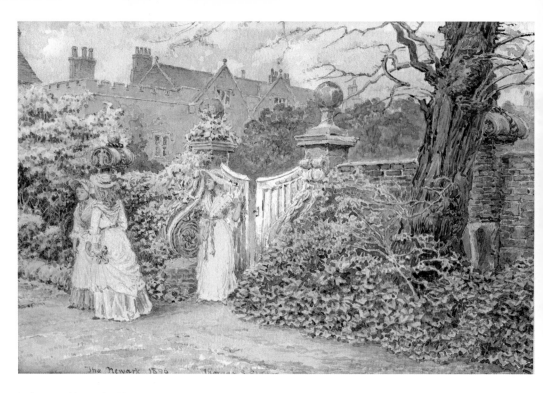

Leicester Newarke Houses

The Leicester artist Thomas Elgood painted this idyllic picture of the Newarke in 1896. It was a scene which would change dramatically within a few years. However, the roofline and chimneys of Skefffington House, now part of the Newarke Houses Museum, are evident in Elgood's painting as well as a small part of the roof of Wyggeston's Chantry House.

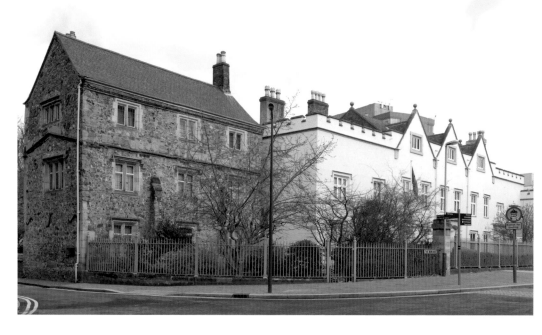

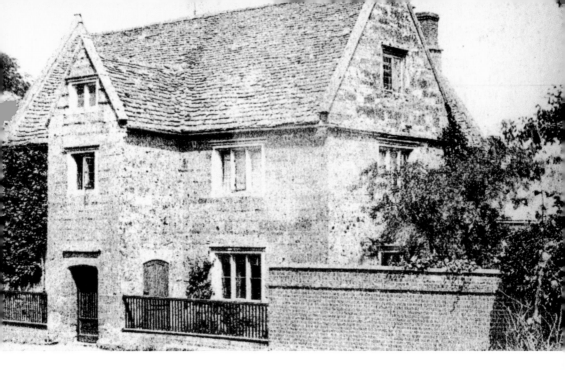

Little Bowden Rectory

This delightful house dates from 1627. Its soft yellowish stone is more common in villages south of here, and indeed Little Bowden was in Northamptonshire until boundary changes in 1891 and again in 1895.

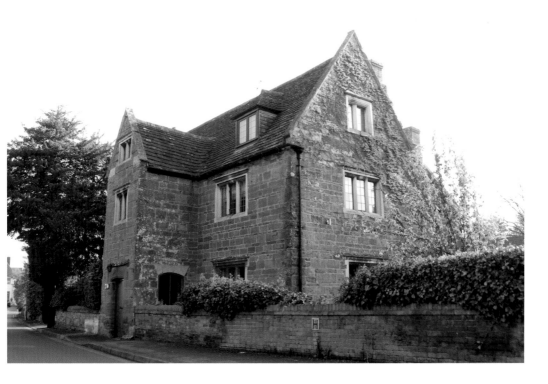

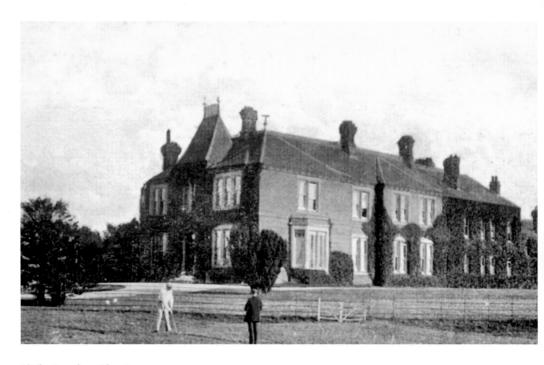

Little Bowden, The Barn

An unusual name for a grand country house, but The Barn, overlooking Market Harborough, was designed in the late eighteenth century as a hunting lodge. The owner, Edward Kennard, also created a nine-hole golf course in about 1900. The house was destroyed by fire in 1912. Today, stylish but smaller residences line the original drive which is named Shrewsbury Terrace after another former owner.

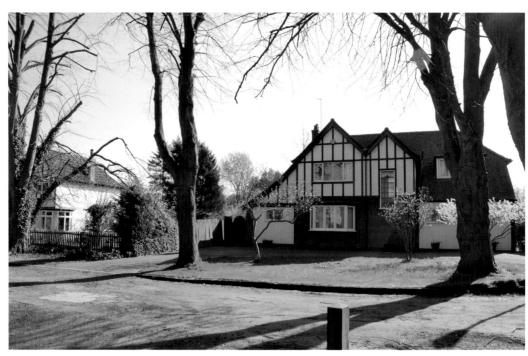

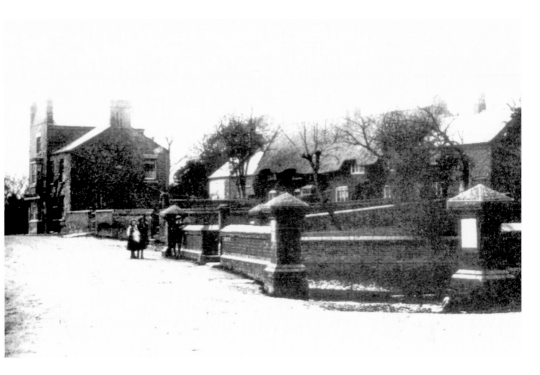

Lubbenham Village Pond

Originally, this area was known locally as the 'town pit'. It was a pond, and the walls around it date from 1869. This photograph was taken about forty years later. In 1949, the pond was filled in and a war memorial constructed above it. Some of the parapets of the nineteenth-century wall remain.

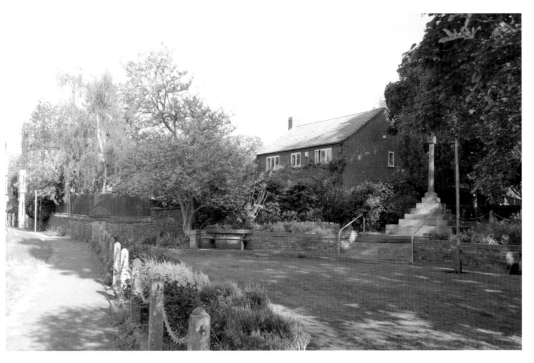

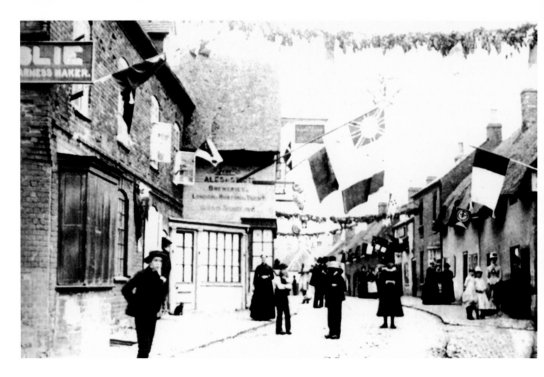

Lutterworth – Station Road

When the Great Central Railway arrived in Lutterworth in 1899, it brought commerce and promoted local industry. Along the street from the centre of the town to the station, many businesses prospered. The line closed in 1966 and the station was later demolished prompting a slow decline in the fortunes of the street.

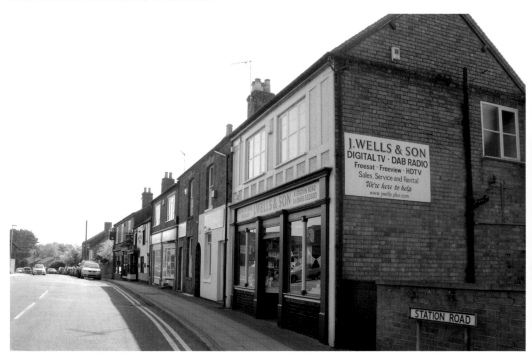

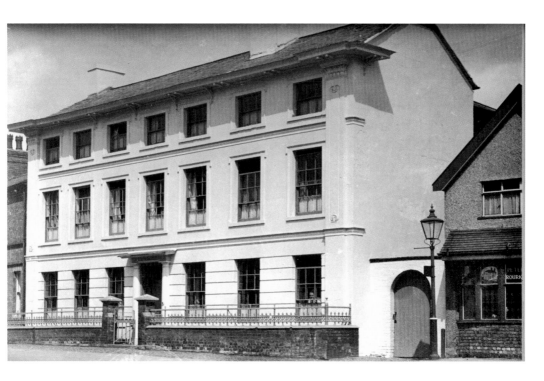

Lutterworth Town House

A dignified and stately building on Lutterworth's main Market Street which loses none of its dignity by now being painted in pink. This is very much in keeping with the predominant architectural style of the town.

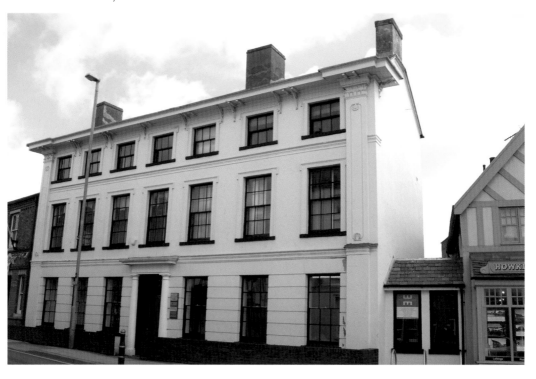

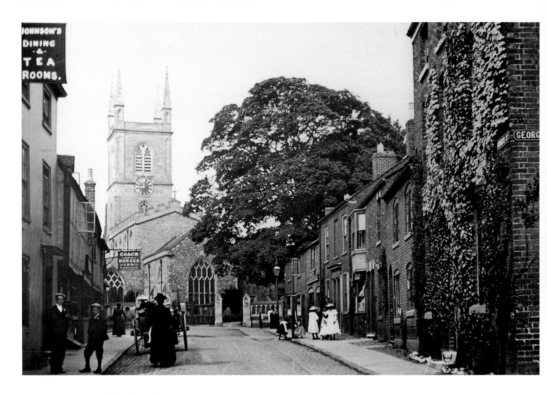

Lutterworth, Church Street

The Parish Church of St Mary looks down upon the busy street. Children are playing, men are passing the time of day and the women are shopping. Near the church gate is a group of gowned figures. The dissident preacher and Bible translator John Wycliffe was rector here from 1374 until his death in 1384.

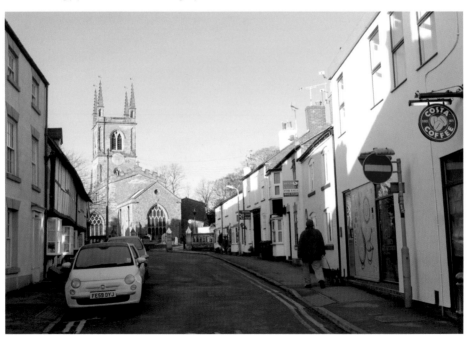

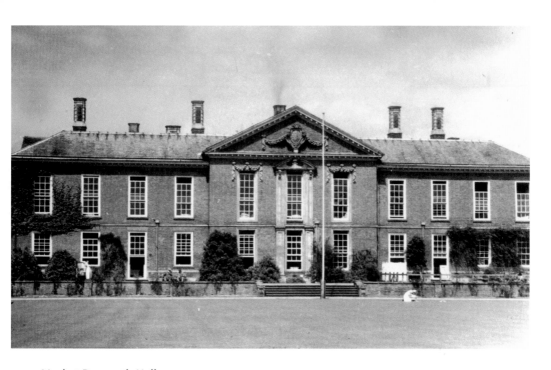

Market Bosworth Hall
The hall which dates from the early eighteenth century is now a hotel, but served as a wartime hospital. It has been frequently altered, both in the nineteenth century and later. The interior is almost entirely altered from the original but is lavish and impressive.

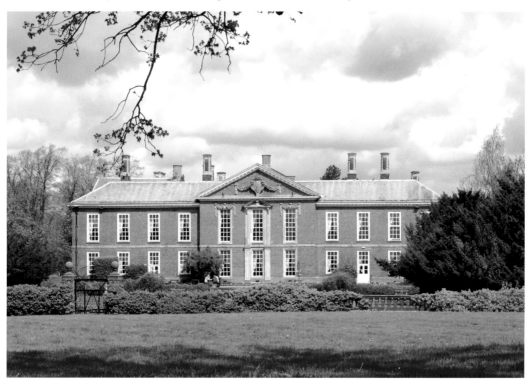

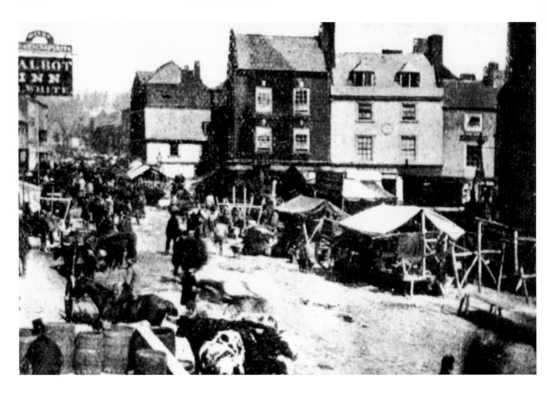

Market Harborough Market Place

This is a rare, early photograph by one of the earliest female professional photographers in Leicestershire, Susan Jennings. She probably took this picture from her studios above the street. The long exposure has caused blurring of moving figures. The Talbot Inn became the Market Tavern and is now a pizza and pasta restaurant. The market, held here since 1219, was moved to an indoor hall in 1992.

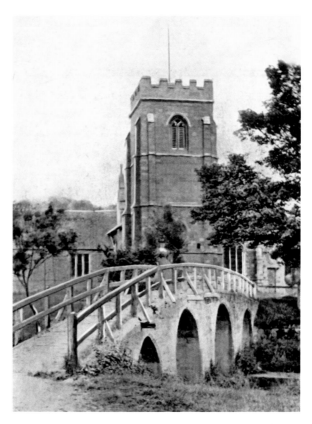

Medbourne Parish Church and Pack Horse Bridge
The bridge is said to date from the thirteenth century and is situated in the centre of this ancient village, but there may have been an even earlier crossing of the Medbourne Brook nearby on the line of the Roman Gartree Road. Less than 150 metres away, evidence of a Roman villa was discovered 1721, and an elaborate mosaic pavement was recorded in excavations in 1877.

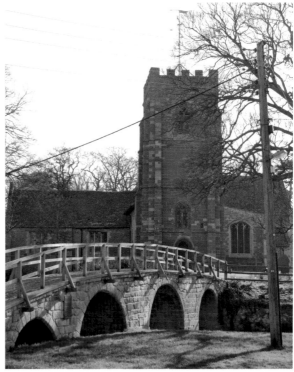

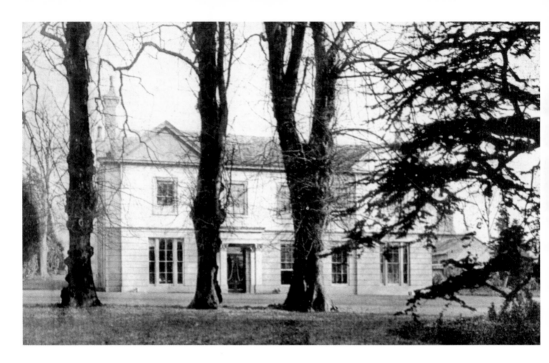

Medbourne Old Rectory

The Old Rectory which stands in secluded gardens still surrounded by tall trees, dates mainly from about 1830 and may stand on the site of its medieval predecessor. It certainly contains elements of two earlier buildings from the seventeenth and eighteenth centuries. It was sold by the church in 1952 for £3,800 when a new and much smaller rectory was built in the paddock behind.

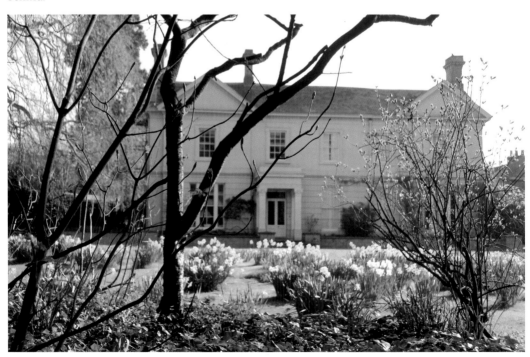

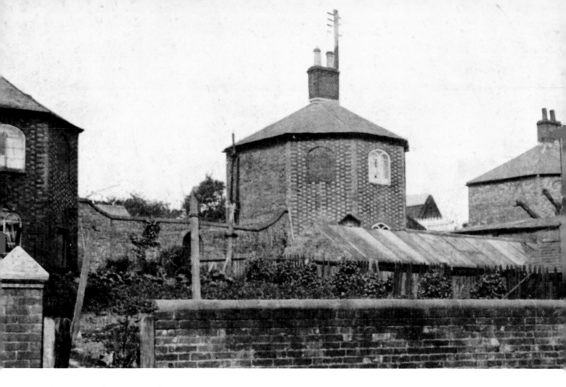

Melton Mowbray Round Houses

In the eighteenth century, a Mr Stokes built three octagonal-shaped buildings known as the Round Houses in the extensive grounds. They were unique in England and attracted visits by historians and architects. The house was demolished in 1932 to make way for Woolworths and other shops in Sherrard Street, but two of the Round Houses remained until 1979, when they were demolished to make way for a GP surgery.

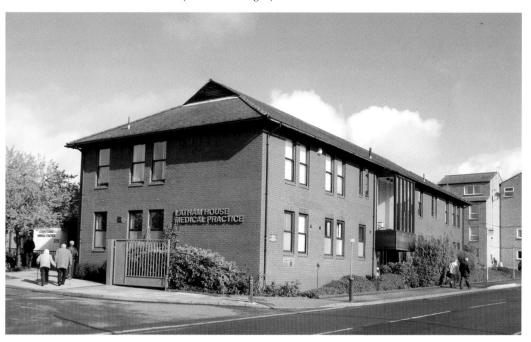

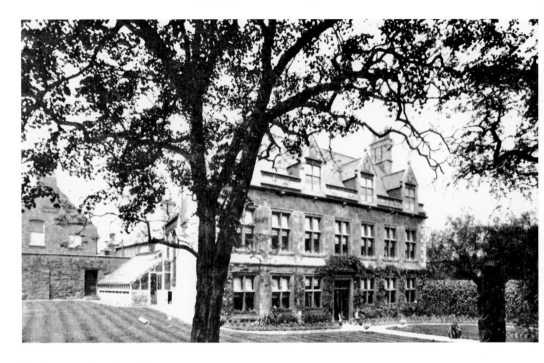

Melton Mowbray, The Limes

The Civil War ended with great rejoicings outside The Limes in Sherrard Street, home of Sir Henry Hudson. His father, Robert Hudson, founded the Maison Dieu almshouses opposite the church in 1640, which complement the stone-built Anne of Cleves House nearby. This was built in 1384 and housed chantry priests until the Dissolution. It was then included in the estates of Anne of Cleves by Henry VIII, as a divorce settlement.

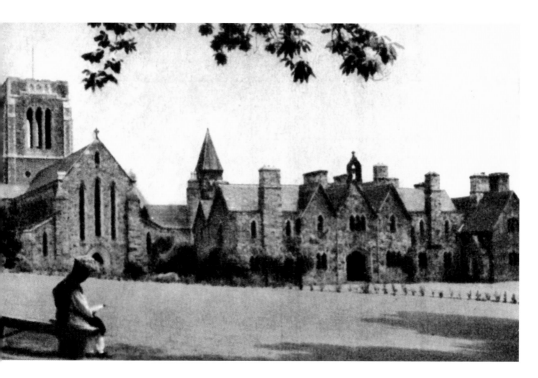

Mount St Bernard Abbey

The Abbey was founded in 1835 on land given by Ambrose de Lisle who wanted to re-introduce monastic life in England. A temporary structure opened in 1837. John, 16th Earl of Shrewsbury, then funded a permanent monastery. Augustus Welby Pugin offered his services free, and in 1844, the new monastery was consecrated. In 1848, Mount Saint Bernard was raised to the status of an Abbey with the first English Abbot since the Reformation, Dom Bernard Palmer.

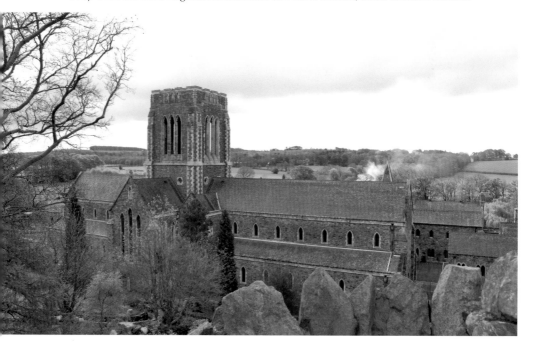

Narborough, All Saints Parish Church
A grave cover dating to the tenth century indicates that this is an ancient religious site. The name of the village derives from the Danish *Narburg* or *Norburg,* the northern part of the Danelaw. The record of incumbents dates back to Henry le Myra who was serving the Church in 1143.

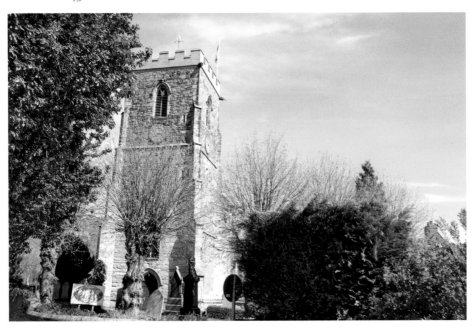

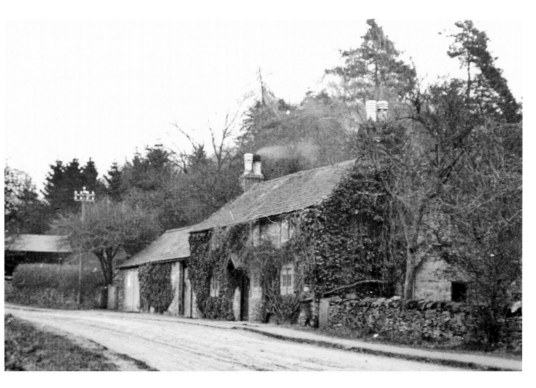

Newtown Linford, Post Office, Tea Rooms and Village Store
Literally a 'new town' created near the ford over the River Lyn for people who were relocated when nearby Bradgate Park was cleared by the Ferrers family. Today, the village is thriving with several restaurants and other amenities catering for the many visitors to the park.

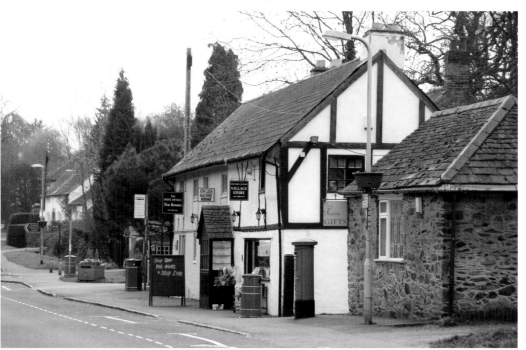

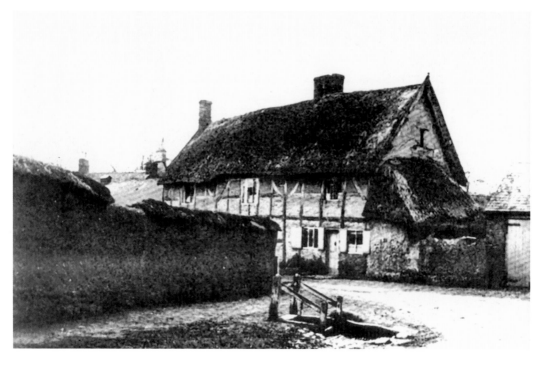

North Kilworth Thatched Cottage
The white-painted half-timbered cottage is a modern design feature of so many villages, but this is original. Often, buildings lose chimneys, but this cottage has gained one in the century between the two photographs.

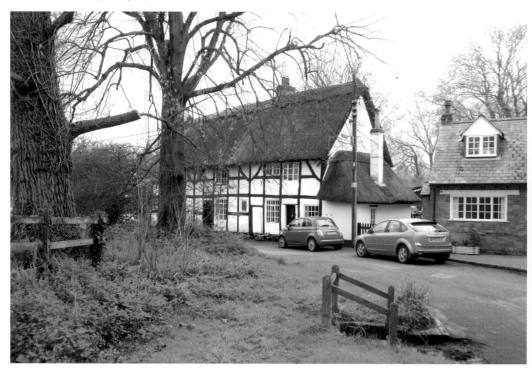

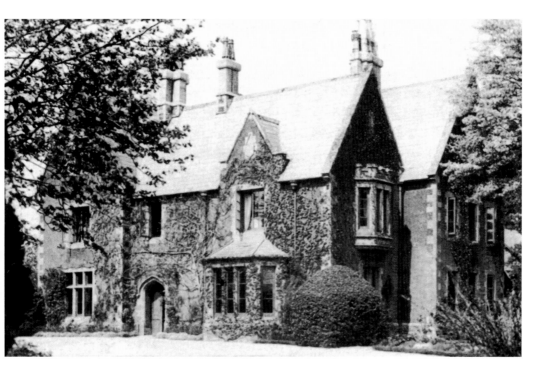

Pickwell Rectory

Pickwell Rectory is a dignified and somewhat gaunt building, its style signifying the standing of rectors in villages during the Victorian period. It is located behind the church in a secluded location. The rector would have had a solitary walk through a woodland landscape to reach his pulpit.

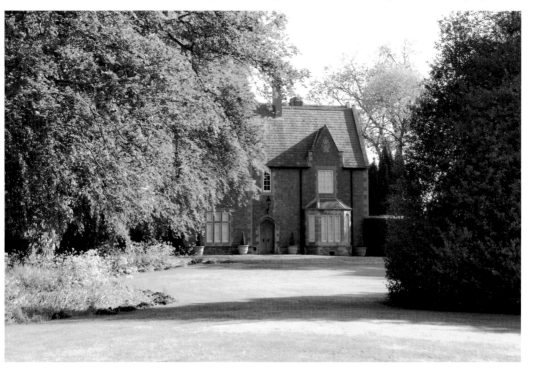

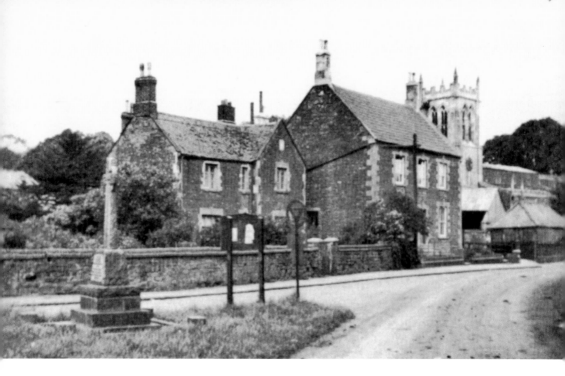

Pickwell War Memorial

Pickwell stands on the very edge of Leicestershire with the landscape of Rutland on the horizon. The theologian William Cave (1637–1713) lived here. His father was the rector. The war memorial stands on a small triangle of grass at the very heart of the village, yet it seems isolated and somewhat overlooked.

Primethorpe Main Street

The earlier settlement of Primethorpe is now the centre of the town of Broughton Astley. It survived for many years as the name of the local post office. In the distance is the Victorian village school. The former village green in the foreground is now the town's shopping centre. A bypass, constructed in the late 1970s, has taken traffic away from the Main Street.

Queniborough, St Mary's Parish Church

The slender needle spire of St Mary's rises to a height of 162 feet above the rooftops of the surrounding village. Most of the church dates from the thirteenth century but there is significant evidence of much earlier stonework.

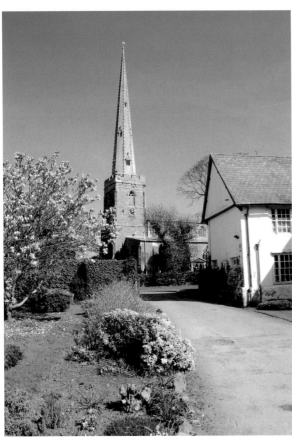

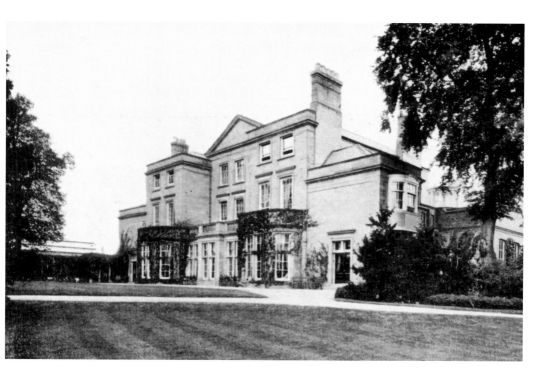

Quorn Hall

The hall by the side of the River Soar was built in about 1680 by the Farnham family, possibly on the site of an earlier structure. Its most famous owner was Hugo Meynell, who founded the Quorn Hunt. The hall accommodated naval personnel during the Second World War and until 2012 served as an international education centre run by Leicestershire County Council.

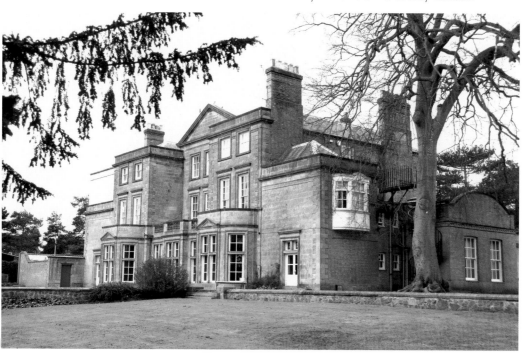

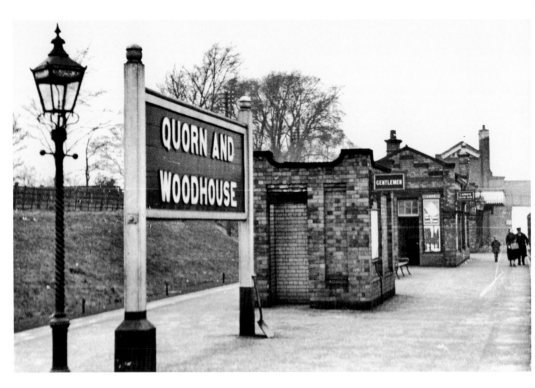

Quorn and Woodhouse Station, Great Central Railway
Each station on the Great Central Heritage Railway represents a different era. Quorn and Woodhouse station reflects the 1940s when railways played a major role in moving troops, provisions and armaments across England.

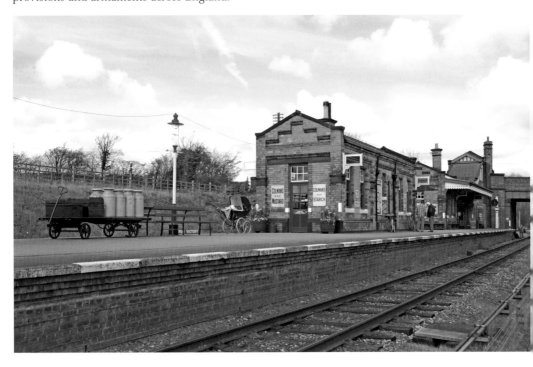

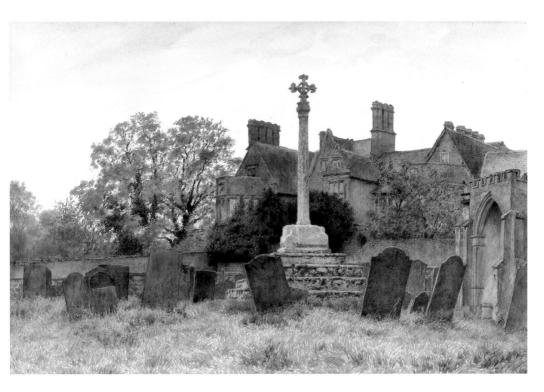

Ragdale Church and Cross

Wilmot Pilsbury, the first headmaster of the Leicester College of Art, painted this image of the churchyard and cross at Ragdale in 1901. Clearly he was more interested in the hall than in the church of All Saints which dates to the thirteenth century. Pilsbury's attention to detail should be celebrated.

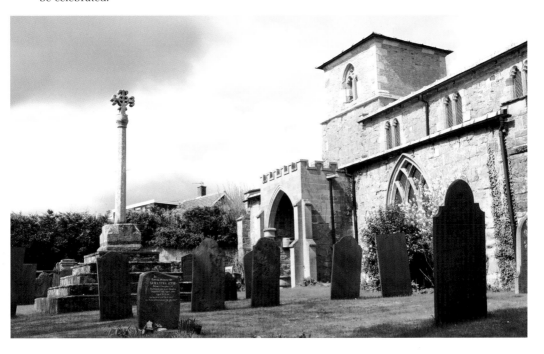

Ragdale Old Hall

Just a retaining wall survives of Ragdale's Elizabethan Old Hall, reputed to be one of the finest of its kind in England. Built by Sir John Shirley as a falconry lodge and enlarged by later generations, it fell out of use when the new hall (now the health hydro) was built in 1785. The Old Hall was converted into rented farmhouses and became neglected until it was finally demolished in 1956.

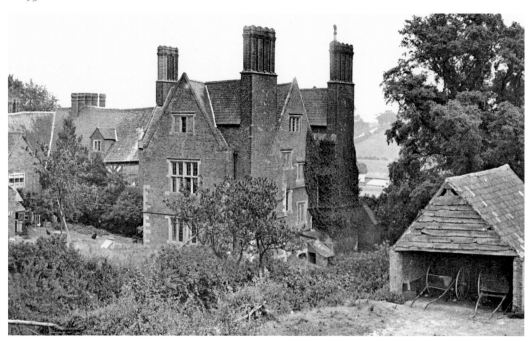

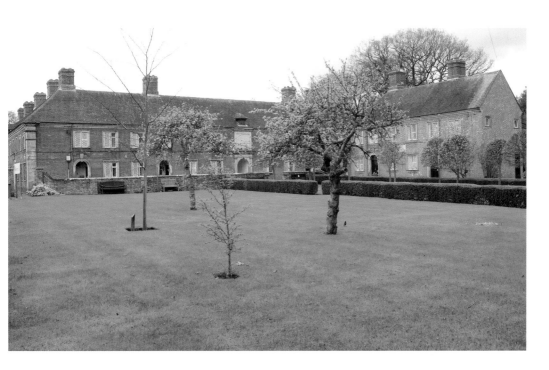

Ravenstone – Almshouses

The hospital was built by John Wilkins of Ravenstone Hall in the early 1700s after the death of his wife, Rebecca, to accommodate thirty poor women from the area. Each resident received 3s 6d per week and wore a gown of grey serge. Two wagon loads of coal were given to each, annually, and residents had to attend prayers each morning. The hospital and trust celebrated its 300th anniversary in 2011.

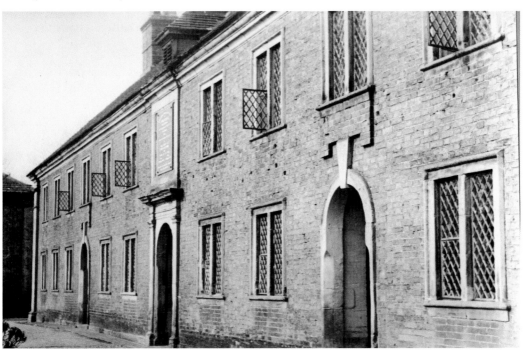

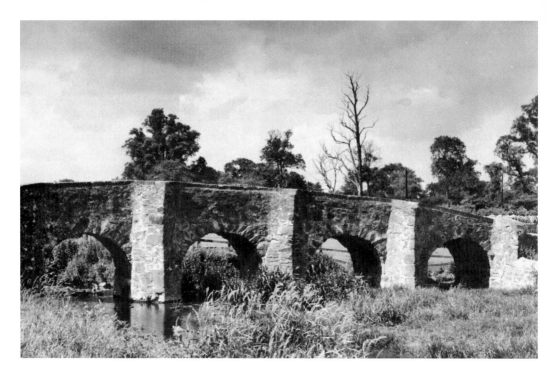

Rearsby, Pack Horse Bridge

This ancient bridge runs parallel to Church Lane in the village and probably dates to the sixteenth century. There are seven arches in total, three over the stream and four smaller arches on the southern approach. On the eastern side, visible in the older photograph, are three cutaways or refuges, of which one is built in brick rather than granite.

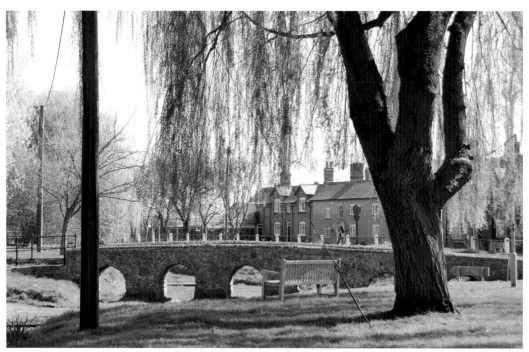

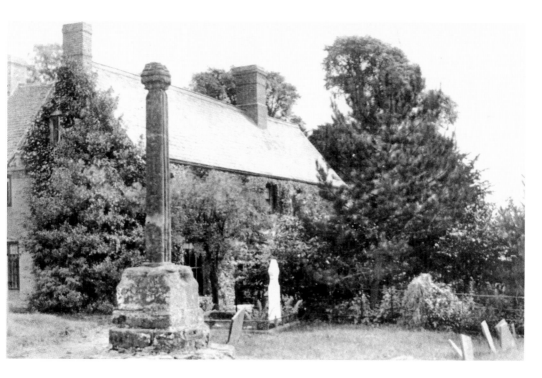

Scraptoft, All Saints, Preaching Cross

A scheduled ancient monument, the preaching cross in Scraptoft churchyard was constructed in the fifteenth century or earlier, and restored in 1964. Part of the lantern top has been lost since the earlier photograph was taken in about 1895. Preaching crosses were usually erected on village greens or market places, more rarely in churchyards.

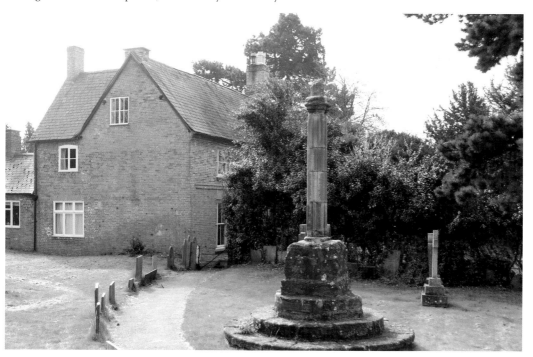

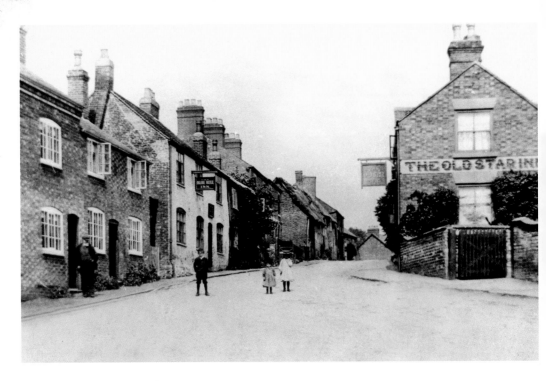

Sharnford, Leicester Road

Just three miles from the major A5 Watling Street, Sharnford was a key stop on the coaching routes to and from Leicester, and was on the route to Watling Street from Leicester. The Old Star Inn survives as the Sharnford Arms. A landscaped public space marks the site of the former Bluebell Inn.

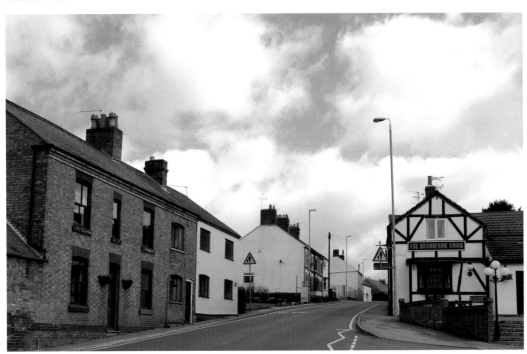

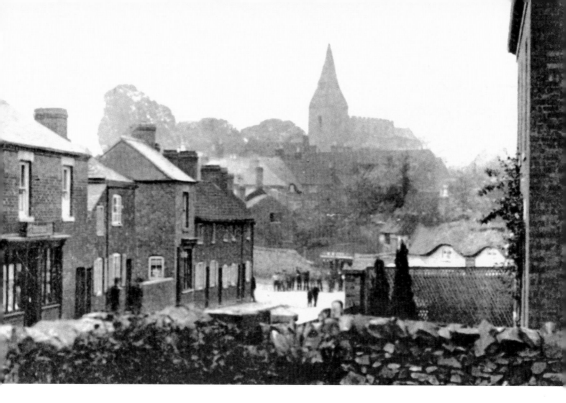

Shepshed, St Botolph's Parish Church

A century ago the church dominated the village. Today, Shepshed is a large and sprawling residential area with the church now seemingly isolated. The older image was taken in 1887, Queen Victoria's Golden Jubilee year.

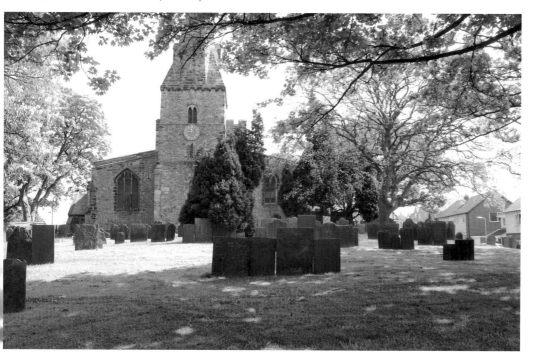

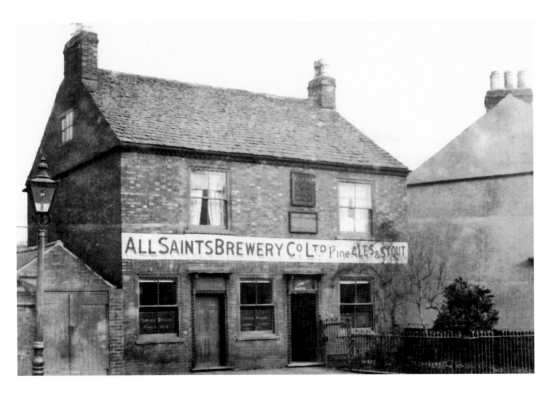

Sileby – General Sir John Moore Pub

The General Sir John Moore stood on the corner of High Street and Brook Street. The front area was known locally as the 'hard padded earth' on which a crockery stall once stood. The pub is now the local chip shop.

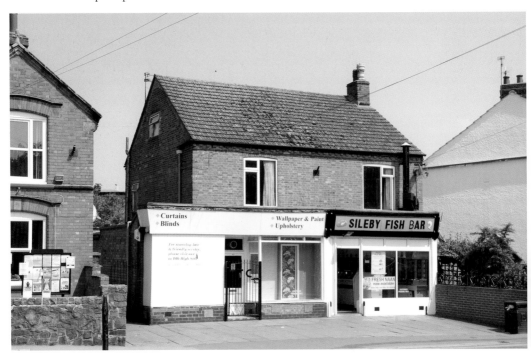

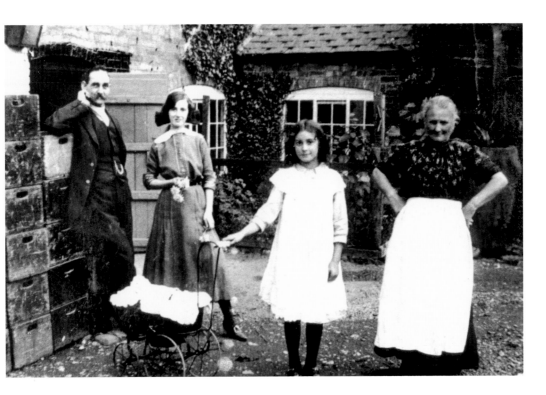

Smeeton Westerby, The King's Head

A thriving village inn which has been the heart of its community for centuries. The building was rebuilt in 1881, and in 1937 a small corner cottage was demolished by the brewery to enable beer to be delivered to the rear of the pub. In the backyard, the landlord and his wife pose with their daughters.

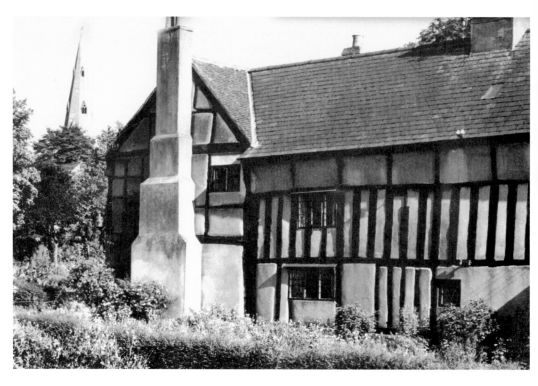

South Kilworth Yeoman's House
A fine example of a prosperous yeoman's house dating from the mid-sixteenth century, located at the heart of the village, near to the village green and church. A building of extensive proportions, it was photographed in the 1940s by Frederick Attenborough.

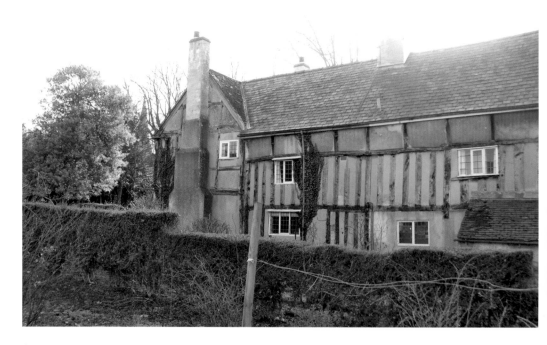

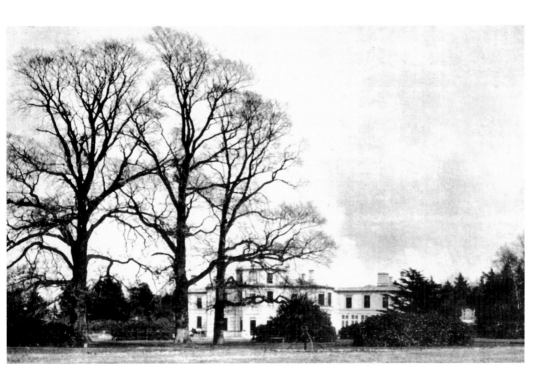

Swithland Hall

Completed in 1834 after fire had destroyed the original hall on an adjoining site, Swithland Hall, with its Greek columns and first-floor oriel, seems strangely out of keeping in the English landscape. It was designed by James Pennethorne for G. J. Danvers-Butler, later the Earl of Lanesborough. The varied use of granite, local slate and brick is disguised by the painted stucco finish.

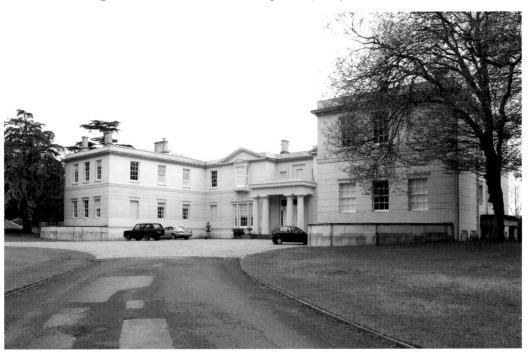

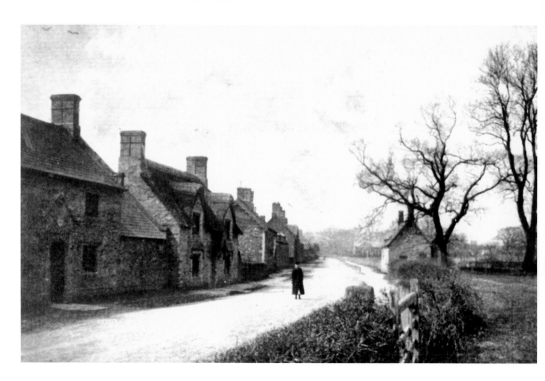

Swithland Street

Swithland is a linear village: the main street is very much *the* village, although there has been some development along side roads. It has had a long association with slate quarrying since Roman times, which is commemorated by a memorial stone situated on the street. The quarry sites have now reverted to nature and there is little evidence remaining of the extent of the industry in its heyday.

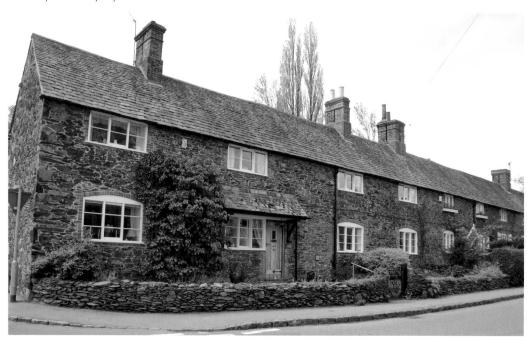

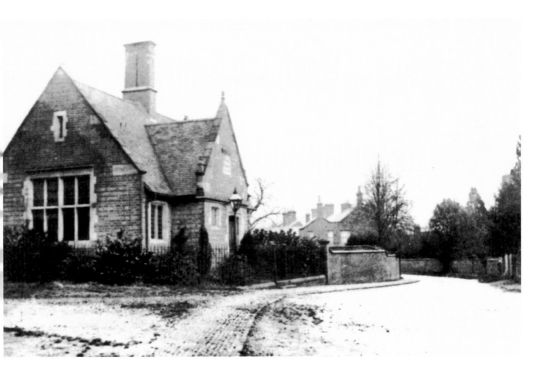

Theddingworth, the Smeeton Institute

This neat building of considerable character is now the village hall. It was built in 1893 by a local man, John Smeeton, as a village recreation and reading room in memory of his son Percy who died in 1889.

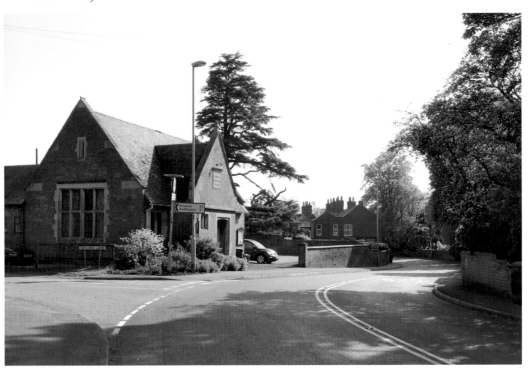

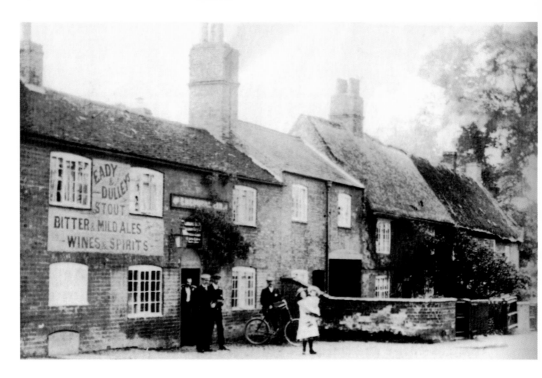

Tur Langton Chequers Inn
At one time the small village of Tur Langton had three public houses. Only one now remains.
The Chequers was situated on Main Street near the edge of the village. This earlier photograph
was taken in about 1905.

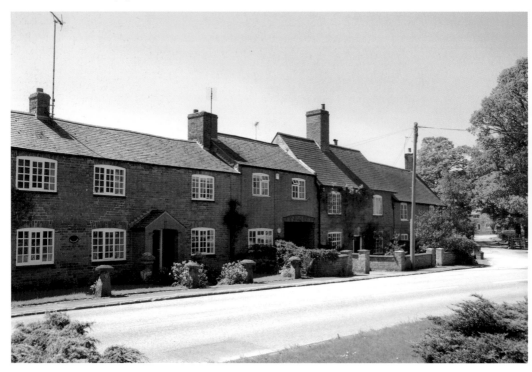

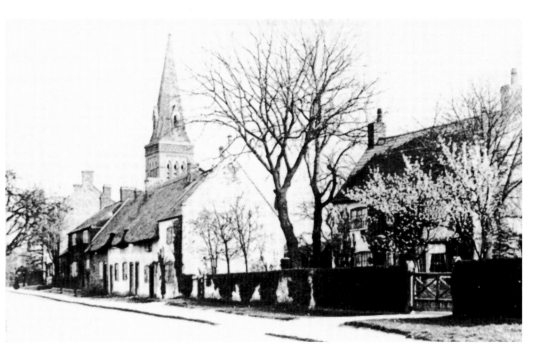

Tur Langton Main Street
The tower spire of St Andrew's dominates the cottages on Main Street. Designed by Leicester architect Joseph Goddard, the church is an unusual but successful example of the Early English style built in exposed brick in 1866.

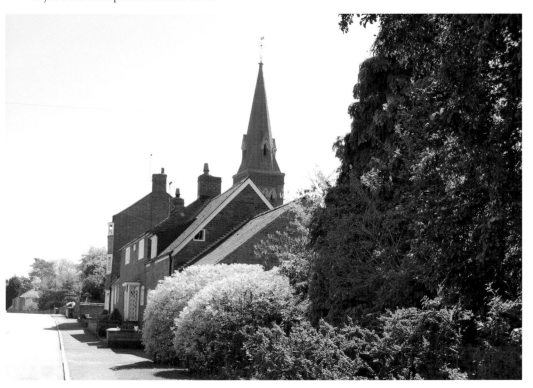

Twyford Main Street

The settlement's name derives from two fords, although there are now three bridges in the village. The Oddfellows Hall, built in 1908, is now the village hall. St Andrew's Parish Church is in the distance.

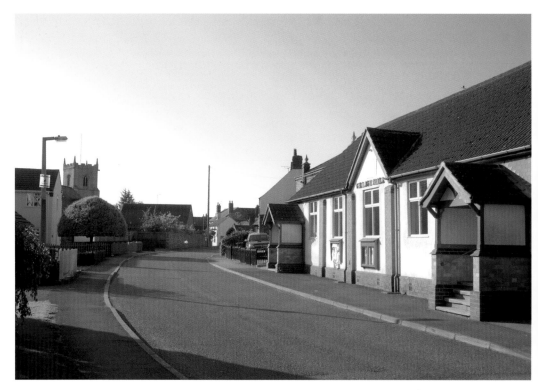

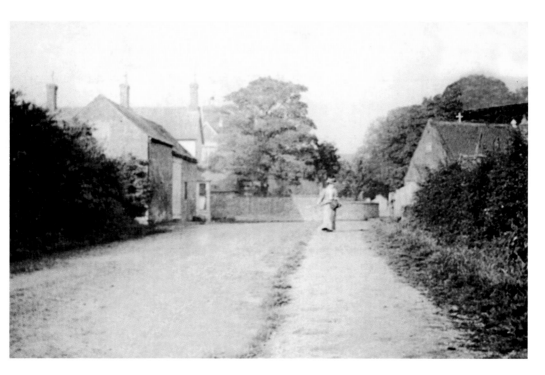

Twyford White House Farm

Looking along the Burrough Road towards the village, in this very early photograph, the former National School is on right, opposite the White House. Loseby Lane is on the left.

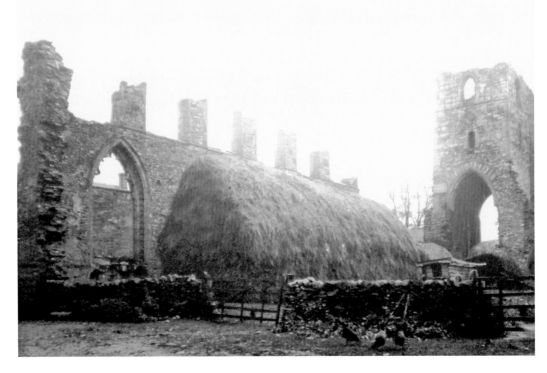

Ulverscroft Priory

The priory of St Mary in Ulverscroft was founded in 1134 by Robert Earl of Leicester and taken over by the Augustinians in 1174. The ruins date from the thirteenth century. Nearby are a moat and three fishponds. Following the Dissolution, the priory was granted to Thomas the 1st Earl of Rutland. The prior's lodging was converted into a farmhouse in the seventeenth century and underwent renovation in 2012.

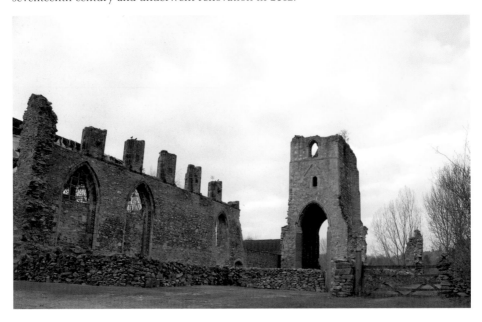

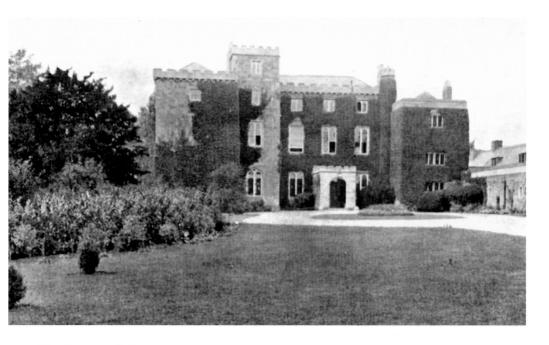

West Langton Hall

Built in the early 1600s, West Langton Hall has seen many owners and occupiers. Hugo Meynell brought the Quorn hounds here in the 1770s to hunt south-eastern Leicestershire, and the antiquary Thomas Staveley, who died in 1684, was born here. A more recent owner was Robert Spencer, cousin to Princess Diana, who maintained a wild bird sanctuary in the grounds. Some claim the building is haunted: an alleged blood-stained floorboard is said never to dry out.

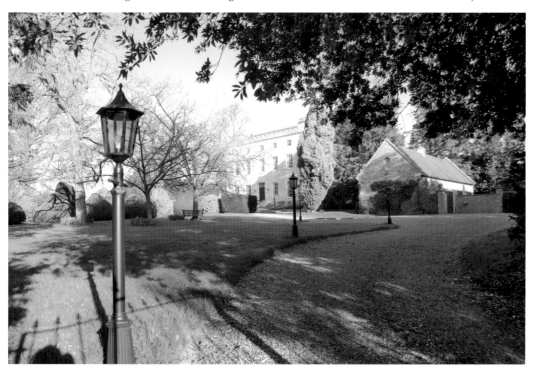

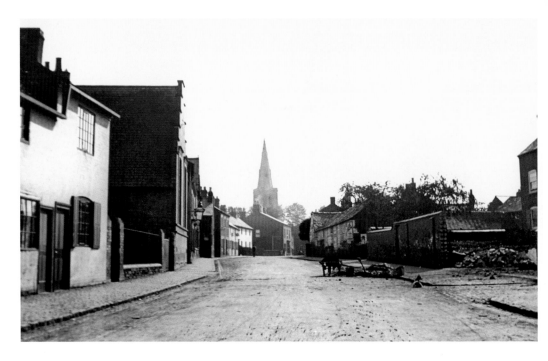

Wigston, Long Street

The older image is from a lantern slide and was taken in about 1895. The Greater Wigston Working Mens' Club, looking more like a chapel (on the left), opened in 1869. There is much charm in the comparative emptiness of the picture: a dog sits beside a wheelbarrow, a shovel and a bucket. In the far distance, a horse-drawn carriage is approaching.

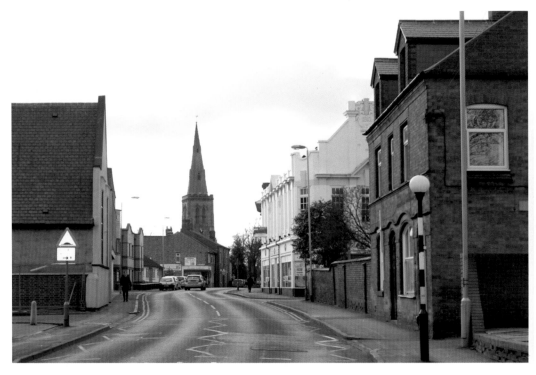

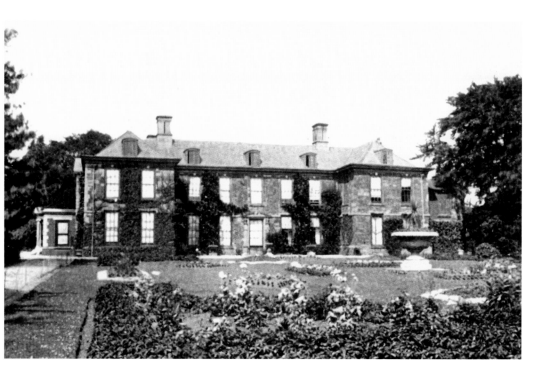

Withcote Hall

Withcote is one of Leicestershire's least-known architectural treasures. It is said to have been built by Matthew Johnson who died in 1723 and who purchased the estate from the poet and favourite of Charles II, Lord Rochester. There are richly worked plaster panelled ceilings in two rooms, probably the work of Italian craftsmen.

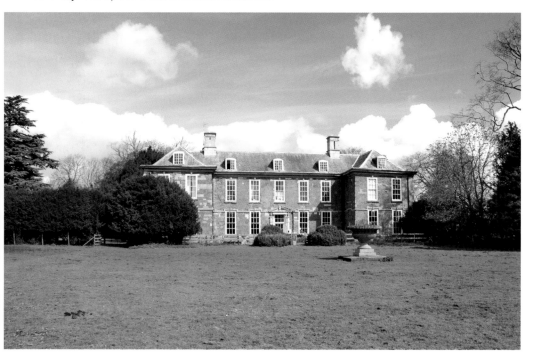

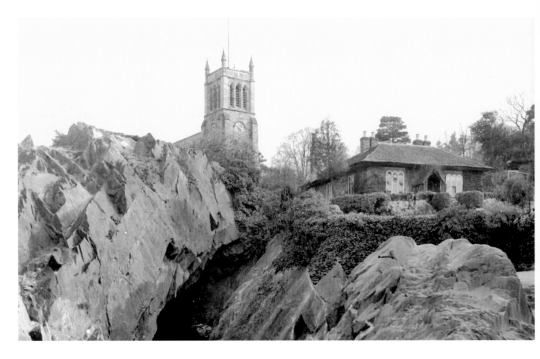

Woodhouse Eaves, St Paul's Church

The church was built in 1837, some forty years after the local Baptist Church, from local materials quarried from the Stone Hole just beneath Church Hill. It was designed by William Railton, who also designed Beaumanor Hall and Grace Dieu Manor in Leicestershire, in addition to his more well-known creation Nelson's Column in Trafalgar Square.

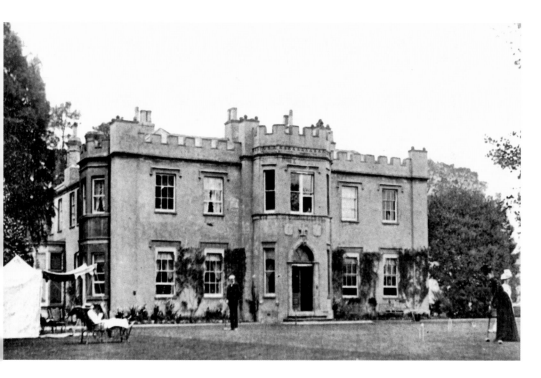

Woodhouse, Garat's Hey

The family which owned this country house in the nineteenth century could not have foreseen that their home would become a secret government installation. It was first used for billeting staff working at nearby Beaumanor Hall, but intelligence training continued here until 1998, when the old hall was demolished to make way for the Welbeck Defence 6th Form College

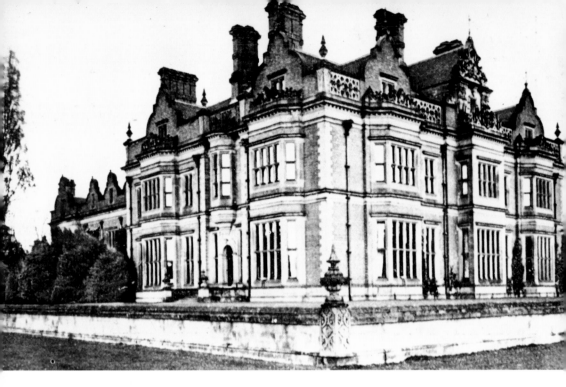

Woodhouse (Old), Beaumanor Hall

Built in the nineteenth century for the Herrick family from red bricks made in the local village, Beaumanor Hall played a vital role in the Second World War as home to a secret signals unit working alongside Bletchley Park. It was purchased in the 1970s by Leicestershire County Council and is now a busy conference and education centre.

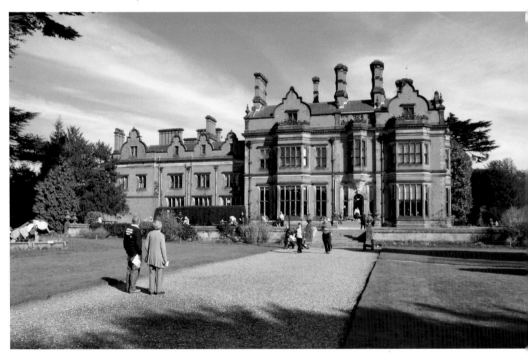